MODERN
BRITISH
SCULPTURE

FROM THE COLLECTION

Penelope Curtis

ISBN 0-946590-99-0
Published by order of the Trustees 1988
for the collection display,
7 September 1988 for three years.

Catalogue compiled and written by
Penelope Curtis with
the assistance of Janis Lyon

Published by Tate Gallery Publications,
Tate Gallery Liverpool, Albert Dock,
Liverpool L3 4BB

Designed by Pentagram Design Limited

Printed in Great Britain by
Ashley Printers Ltd.

Photo credits
Tate Gallery Photographic Department
The Conway Library, Courtauld Institute
of Art p21

© David Nash, all rights reserved DACS,
1988, work by Schwitters by permission
of © COSMOPRESS, Geneva, DACS,
London 1988

Cover
Henri Gaudier-Brzeska
Red Stone Dancer c1913

Naum Gabo
Linear Construction No.1 Variation 1942-3

Tim Scott
Agrippa 1964

All measurements are in millimetres
(in the order: height, width, depth).

CONTENTS

Although a number of British painters have won international recognition in the twentieth century, it is in the field of sculpture that British artists have enjoyed particular acclaim. Following the success of Henry Moore at the Venice Biennale in 1948 the work of successive generations of sculptors has been received with equal interest in international exhibitions across the world.

The Tate Gallery has been an active collector of sculpture and many of the most significant works of the period are now to be found in the collection. At the same time the Gallery has been able to strengthen its representation of early twentieth century sculpture through selective purchases and a series of generous gifts, not least that of Henry Moore himself.

However, given the overall shortage of space at Millbank and the fact that many of the galleries there are more suited to painting, it has rarely been possible for the Tate to present an adequate survey of developments from the earliest years of the century. Now the Gallery has an opportunity to examine those developments and to demonstrate the richness of the collection for the first time, not in London, but in Liverpool, where the Gallery is especially suited to the display of sculpture.

This exhibition, which will remain in Liverpool for three years, is the first in a series of displays which will present parts of the Tate collection in depth. It has been selected to provide a chronological survey, essentially from the moment that British sculptors such as Epstein and Gaudier-Brzeska and Eric Gill discovered primitive and archaic sculpture and began carving directly in stone. All the major sculptors of the period are included, and with one exception the display is drawn entirely from the collection.

The Tate is most grateful to the Granada Foundation for their generous loan of Epstein's magnificent *Jacob and the Angel,* seen last year as the centrepiece of the Royal Academy's survey of British Art in the Twentieth Century. The building and programme in Liverpool have enjoyed financial support from the Government, but could not have been realised without very significant commitments from the private sector. The Trustees are grateful to the Henry Moore Foundation for their assistance on this occasion. They joined Imperial Chemical Industries to support our inaugural exhibition *Starlit Waters* and have helped here with funds for equipment and the preparation of works. The Foundation continues to assist the Tate in several ways, notably through their support of our research and work in the conservation of sculpture. It is therefore especially appropriate that my predecessor Sir Alan Bowness, who was primarily responsible for the initiative which led to the opening of the Tate in Liverpool, should become Director of the Henry Moore Foundation at the moment when this display of sculpture opens.

Nicholas Serota
Director
Tate Gallery

Richard Francis
Curator
Tate Gallery Liverpool

The present display is based on the belief that Tate Gallery holdings make a viable display of modern British sculpture, and that we can claim that it is a survey show. The Tate Gallery has over one thousand sculptures in its collection, and here we are presenting nearly 15%. It has also been possible to exploit the transferrals of sculpture made in 1983 from the Victoria and Albert Museum. The selection was made by several people (David Fraser Jenkins in London has worked with Tate Gallery Liverpool Curators) and the final list is not attributable to any one curator, in London or in Liverpool. However, to a large extent, and especially for the earlier period, unanimity was easy. Discussion devolved not on 'who' to include, but rather on 'which' of their sculptures to include. The nature of the Tate collection dictated what kind of 'Modern British Sculptors' could be exhibited. The periods in which choice has been more actively exercised fall at the beginning and end of the period. While, for the bulk of the twentieth century, the Tate has pursued a modernist collecting policy, it has inherited the uneasy legacy of Edwardian sculpture acquired in the early years of the century. Thus, it would have been possible to include sculptors such as Bayes, Reid, Dick, Fehr, Frampton, Goscombe John, Hartwell, Reynolds-Stephens, Toft, Tweed, Derwent Wood and Mac-Kennal. Such artists would now be classified as academic, but were then seen as modern. It might have been interesting to juxtapose them with the artists in the first section of the display: Gaudier-Brzeska, Epstein and Gill. However, it could be seen as justifiable to exclude them as an earlier generation, despite the fact that their works date from the period up to the First World

War. The possibility of showing an alternative face of British sculpture from the Tate Collection extends into the thirties (with works by sculptors such as Garbe, Gordine, Hermes, Lambert, Ledward and McMillan). After this date it would not in fact have been possible to present a selection of sculptors much different from that in our display.

The other area in which choices have been made, more rigorously, is that of the last ten or even twenty years. The collection represents more artists, and of course, art historical decisions are less easy to make for a more recent period. We were disappointed that this display could not be shown *in tandem* with the exhibition of British sculpture 1968-88, *Starlit Waters,* and this has made decisions more, rather than less, difficult. Its focus on the 'conceptual' sculpture of the sixties and seventies has perhaps led to this genre being underplayed in the current display. Photowork is also poorly represented. The display has tended towards showing objects rather than theories. Various artists could have been included who might have represented various trends since the early seventies; Ivor Abrahams, Stephen Willats, Boyd Webb and Braco Dimitrijevic. Representation of the seventies has suffered in the effort to bring the survey up to the present. This effort has been made because it was felt that a display lasting three years (long after *Starlit Waters* ends) should take us up to our own time.

A few, but suprisingly few, omissions are due to conservation reasons. Had their works been in a more stable condition, Fullard, Koenig, Latham, Pope and Startup would have been included in the display. A few other works by artists already in the display have been rejected on similar grounds.

Apart from the limitations imposed by the nature of the Tate collection, other reasons have informed the original intention to present a straightforward survey of 'modern' twen-

tieth-century British sculpture (as it has been standardly and rather loosely set out within a generalised framework of modernism – the autonomy of the art object – and the avant-garde). The method of display is clearly neither quirky, nor idiosyncratic. Its nature, combined with its duration, is intended to make it feasible for schools and colleges (and individual members of the public) to fit it into a learning process. It should be seen as a learning resource, which is best treated as something to come back to at regular intervals. The catalogue has been designed with this in mind. It is divided into broadly chronological sections, then into artists, and then into works.

There are bound to be parallels drawn between this display and the temporary exhibition presented at the Whitechapel Gallery, London in 1981-2. That show, *British Sculpture in the Twentieth Century* – which had twice as many exhibits (and it was notable how many came from the Tate Gallery's collection) – had a catalogue with essays by different invited authors; it also sought to throw light on sculpture and sculptural genres that had long been submerged. It was constructed with loans from several institutions, including the Tate Gallery.

British sculpture has tended to have been analyzed in terms of generations, and this 'analysis by generation' has been exacerbated by the strength of the British art schools in terms of training and affiliation. The art school has been central to the practice and discusssion of British art since the last war, and perhaps as early as the twenties, when Moore began to teach at the Royal College. The master-student relationship has been fostered outside the art school by Moore, and later by Caro, who took many young students as assistants. Another tendency which has developed since the war, but which was also clearly visible in the first half of the century, is the critics' obsession with a national school of

sculpture. The promotion of Moore and Hepworth after the war encouraged the nascent idea that a 'British School' existed, and indeed, that sculpture was a particular British strength. As other countries' expectations of this school were fostered, so they appear to have been met. After Moore came the 1952 Venice Biennale. After Caro came the 'New Generation'. Even now, contemporary British sculpture is iden-tified abroad as both unusually British, and unusually sculptural.

Penelope Curtis
Assistant Curator,
Exhibitions and Displays

THE BEGINNING OF MODERN BRITISH SCULPTURE

The display begins with the sculptors who have been acknowledged as those with whom we see the birth of modern sculpture in Britain. It was a strange birth in that it involved a Frenchman, an American, and a deeply committed Catholic craftsman, and because the new ground it broke was soon forgotten with the war. After the war, we see a fresh awakening, and what might be called a second beginning.

Gaudier-Brzeska, the Frenchman, Epstein, the American, and Gill, the religious craftsman, were all born at the beginning of the 1880s. At the time when they were starting their careers, Late Victorian sculpture was reaching its apogee, and the Edwardian era beginning. The 'New Sculptors' of the end of the nineteenth century, who had brought with them a breath of fresh air in terms of the varied materials they employed, the broad scope of purpose that they found for sculpture, and their humane and charming subject-matter, had by now become the artistic establishment. They received important commissions for monuments and statues, they were the professors at the art schools, and they sat on the juries that awarded the prizes. It tends to be their work which still dominates our streets and squares wherever there are public statues. Frampton, Pegram, Goscombe John, Pomeroy and Brock are all represented in Liverpool (in St. John's Gardens and on the Pierhead), and even the pioneer 'New Sculptor', Alfred Gilbert, is represented with a version of his 'Eros' fountain in Sefton Park. All these sculptors were born in the decade after 1854. Yet even when Barbara Hepworth and John Skeaping (see next section) competed for the Rome Scholarship in 1924, the jury included Frampton, Goscombe John and Pomeroy. Such

11

'figures from the past' cannot in fact be pushed back into the 19th century, for they were very much living presences well into the 20th. The Royal Academy summer ex-hibition of the first two decades of the twentieth century continued to be dominated by Victorian or, at best, Edwardian sculptors. It is against this background that the work of Gaudier, Gill and Epstein should be understood, both in terms of this kind of sculptural form (consider, for example, the monuments in St. John's Gardens, which date mainly from the first decade of the 20th century, as does the huge monument to Queen Victoria in Derby Square), and in terms of this kind of sculptural training and establishment.

Epstein and Gaudier came to London from Paris within five years of each other; Epstein in 1905, Gaudier in 1910. Both were inter-ested in Rodin and in non-Western (so called Primitive) sculpture. Ep-stein had an extremely important collection of African and Pacific sculpture, ending up with over 1,000 pieces, many of international status. He had begun collecting at least as early as the French Cubist and Fauve artists, and such art was as important a stimulus for him as it was for them. Both he and Gaudier loved the British Museum (as Moore was to, a little later) and it was his visit there in 1905 that decided Epstein to settle in Britain. For artists looking for a new way to depict the outside world, and express their feelings about it, non-Western art was a tremendously im-portant alternative tradition. That they were fascinated by ethnographic or archaic art did not entail their abandoning classical Western models, and in both artists, we can see two quite distinctive styles, one based on the non-western, the other on the western tradition. These two styles can be respectively equated with carving, and with modelling. The distinction made between these two technical approaches became an ex-tremely important one for the scul-

ptors of the first three decades of this century, and the 'modernism' identified in Gaudier, Gill, and Epstein, was their carving. Gaudier's self-questioning about the superiority of traditions is clearly expressed in a letter of 1912:

'This afternoon I went to the British Museum. I looked particularly at all the primitive statues – negro, yellow, red, and the white races, Gothic and Greek, and I am glad to say I was at last convinced of a thing which had for a long time bothered me. I had never felt sure whether the very conventional form of the primitives, which gives only a enormous impression of serene joy or exaggerated sorrow – always with a large movement, synthetized and directed towards one end – had not a comprehension more true.......than modern sculpture from the Pisani through Donatello up to Rodin and the French of to-day. Having very carefully studied the two aspects, at the moment I think not. My first reason is that primitive sculpture seen in large quantities bores me, whereas modern European sculpture seen in the same quantity interests me infinitely. Now when I think it out I see that in modern sculpture the movement, without being so big, is nearer to the truth. Men do not move with one movement as with the primitives: the movement is composed, is an uninterrupted sequence of movements...'

Gaudier's attempt to capture movement, in the moment that it is held, before it is released into the sequence, is clearly visible in his bronze pieces on display. In his short life, Gaudier developed very quickly. He moved from his admiration of Rodin, to a very distinctive synthetic carved style. Epstein credits himself with having introduced Gaudier to carving: 'In 1911, while I was at work on the Oscar Wilde tomb in my Chelsea studio, a young fellow called on me...and asked if he could see the carving. It was Gaudier Brzeska... He was very pleasant, I thought, and

13

he gave Ezra Pound an account of this first meeting.

'He declared to Pound that I asked him if he carved direct, and that, afraid to acknowledge that he hadn't, he hurried home and immediately started carving.'

The tomb on which Epstein was at work involved a twenty ton block of Hoptonwood stone which Epstein had seen in a Derbyshire quarry. He declared that his sculpture was 'conceived in stone' (and this became part and parcel of the modernist creed of direct carving), and that, having finished it, he now wanted to 'carve mountains'. The thrill of the stone, and the notion that the block contains within it the sculptural form, were to become vitally important to the sculptors and critics of these years. Epstein was certainly aware of the two strands to his work, and exhibited his portraits (which were modelled in clay and then cast) in the respectable National Portrait Society, and his carvings with the London Group. His carvings were viewed with suspicion, and especially when they were carved in large-scale to go on London's public buildings. One critic accused the flenite figures (one of which is on show here) of: 'rude savagery, flouting respectable tradition – vague memories of dark ages as distant from modern feeling as the lives of the Martians.' Epstein's later carvings were big (like 'Jacob and the Angel') or monumental. The small pieces were pre-war, although he considered them highly enough to exhibit them even in the 1930s. While Epstein's portraits were sought by the rich and famous, his carvings could still provoke an outcry even mid-century. In 1932 the *Liverpool Post and Mercury* judged that 'the word "Epsteinism" is a synonym for "art atrocity"', and Epstein was also taken to be a descriptive part of the English language in describing Henry Moore: 'Epstein out-

Epsteined' proclaimed the *Daily Mirror* in 1931. Moore recognized his debt to Epstein for exactly this reason; Epstein had taken the brunt of the press's attack on emergent modern sculpture:

'He took the brick-bats, he took the insults, he faced the howls of derision. As far as sculpture in this country is concerned, he took them first. We of the generation that succeeded him were spared a great deal, simply because his sturdy personality and determination had taken so much.'

In later years, Epstein refused to commit himself to the vogue for direct carving. He asserted, (although he may have been feigning disinterest):

'I am a sculptor. The distinction (between modelling and carving) is purely an imaginary one. Personally I find the whole discussion entirely futile.'

Epstein had been friendly with Eric Gill in his younger days, (before they quarrelled) and Gill carved the inscription on the Wilde tomb, and developed a project with Epstein for a large outdoor group. Gill may well have influenced Epstein to begin carving direct, rather than using plaster models. Gill was important to modernist practices in a slightly eccentric way, in that he fits into a nineteenth-century Arts & Crafts context, concerned about craftsmanship and the role of the artist in the community. In his autobiography he wrote:

'So all without knowing it I was making a little revolution. I was reuniting what should never have been separated: the artist as man of imagination and the artist as workman.'

By executing even the simplest of tasks to the very best of his ability, Gill affirmed the merit of fine craftsmanship, and in doing so, moved from being simply a carver and letterer, to being taken as an artist. This was exactly what he proclaimed against, but his excell-

ence was such that he inevitably stood apart. He saw the beauty in the shapes of letters themselves, so that his inscriptions counted for more than the sum of their words:

'The shapes of letters do not derive their beauty from any sensual or sentimental reminiscence. No one can say that the o's roundness appeals to us only because it is like that of an apple or of the full moon. We like the circle because such liking is natural to the human mind.' Gill was doing well in the lettering trade in the first decade of the century, and also did shop signs, lettering for books, and engraving in wood. He said, 'my work was all lettering, and until about 1909 I don't think I so much as dreamed of doing anything else.'

The thrill of his first carving of a nude woman, of letter cutting, and of his religious faith all come together in this passage in which he describes the experience:

'Lord, how exciting! – and not merely touching and seeing her but actually making her. I was responsible for her very existence and her every form came straight out of my heart. A new world opened before me.

Lettercutting – a grand job, and as grand as ever – the grandest job in the world. What could be better? If you've never cut letters in a good piece of stone, with hammer and chisel, you can't know. And this new job was the same job, only the letters were different ones. A new alphabet – the word was made flesh.'

Gill was one of the earliest sculptors to define direct carving, thus distinguishing it from carving as it had been understood up till then, which involved a craftsman carving the stone version of his employer's modelled work.

'For stone carving', wrote Gill, 'properly speaking isn't just doing things in stone or turning things into stone, a sort of petrifying process; they are of stone in their inmost being as well as their outermost existence.'

'...stone carving is conceiving things in stone and conceiving them as made by carving. They are not only born but conceived in stone...'

He put his direct approach down to the fact that he had received no art-school training, had not been taught how things 'ought' to look, and was instead able to get down to making them. When he first began to carve subjects, rather than letters, his friend Count Kessler identified him as an 'artist', and wanted to make him assistant to Maillol. Of course, to put Gill in such an indirect position in relation to the work would have been anathema to him. Gill was interested in medieval carving, in its anonymous and communal nature, and in its having a purpose. In 1940 he lamented that there had been no breakdown of 'the universally accepted notion of art as being primarily self-expression, the manifestation of the precious personality of the artist. The decay of the idea of art as being on the one hand *ritual* and on the other *service* was the inevitable consequence of the commercial and financial domination which characterizes our world.'

JACOB EPSTEIN
1880-1959

Jacob Epstein was born in New York of Polish-Jewish parentage, and began studying sculpture in America. He went to Paris to see works by Rodin, and Greek sculpture, and in 1905 settled in Britain. He was an early friend of Gill, and later of Modigliani. His work on the facade of the British Medical Association building in the Strand, London, in 1907-8 caused a great scandal in the London press, as did his subsequent public commissions: Oscar Wilde's tomb (1910-11), the W. H. Hudson memorial, Hyde Park (1925), and 'Night' and 'Day' for the London Underground Headquarters Building (1928). The absence of public commissions over the next two decades meant that he executed no more architectural

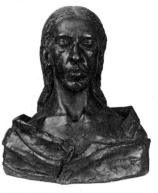

NAN 1909

Bronze

445 x 381 x 229 N003646

'Nan' is a work from Epstein's formative period. She was a gypsy, and professional model, and worked a good deal for Epstein, who made several sculptures and drawings of her. After his large Strand carvings, Epstein decided to re-apply himself to the study of sculpture: 'I again took in hand my development as a Sculptor. After so much that was large and elemental (Epstein had worked on fourteen sculptures nearly 7 foot high over eighteen months), I had the desire to train myself in a more intensive method of working'. He began to work from the model again, very carefully, following the 'forms of the model by quarter-inches', and these studies included the various busts of Nan.

FEMALE FIGURE IN FLENITE 1913

Serpentine

447 x 95 x 121 T01691

The critic Hulme was buying this figure in instalments at the time of his death. It then reverted to Epstein, and was discovered in a trunk after his death. Hulme, with the American collector John Quinn, was among the few to appreciate his carvings. He wrote a defence of them which pleased Epstein so much that he published it in full in his autobiography, and indeed Hulme's early death lost the sculptor an important intellectual supporter. In 1913 Hulme wrote of this piece that 'The design is in no sense empty but gives an impressive and most complete expression of a certain blind and tragic aspect of its subject. The archaic elements are in no way imitative. What has been taken from African and Polynesian work is the inevitable and permanent way of getting certain effects.' Flenite is simply the name that Epstein gave to the very hard stone, Serpentine. The fact that the block depicts a pregnant woman may well relate it to Congo fertility charms.

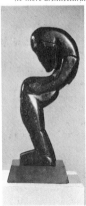

carvings in this period, although he continued to carve on a large scale privately. Towards the end of his career, as his fame increased, he enjoyed new demand for public sculpture in addition to the constant demand for portraiture. Much of this was religious sculpture, to decorate cathedrals. Epstein was finally knighted at the age of 74.

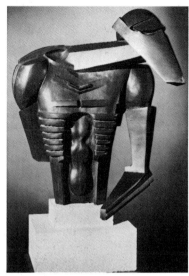

TORSO IN METAL FROM 'THE ROCK DRILL' 1913

Bronze

705 x 584 x 445 T00340

'The Rock Drill' has to be seen in the context of Vorticism, and Epstein's involvement with it. This English group, taking a lead from the Italian Futurists, sought to explode polite English conventions and to modernise art, drawing inspiration from force, speed, the machinery of the modern world, and everything signified in ESSENTIAL MOVEMENT and ACTIVITY. They worked by the medium of shock tactics, writing and behaving in a way that was larger than life. Epstein later wrote, 'It was in the experimental pre-war days of 1913 that I was fired to do the rock-drill, and my ardour for machinery (short-lived) expended itself upon the purchase of an actual drill, ... and upon this I mounted a machine-like robot, visored, menacing, and carrying within itself its progeny...' He even thought of attaching a motor to the drill and setting it in motion. It was first exhibited at the London Group show in reverse to the way we have come to know it: the drill was black metal, the robot white plaster. Critics disliked the mixture of realism and abstraction. Within a year Epstein had removed the drill, and exhibited only the torso, now cast in bronze. It is likely that he, in common with the other Vorticists, now found anything too redolent of war distinctly chilling. The exhilaration previously identified in the battlefield had become, with the carnage, and loss of particular colleagues, outdated and distasteful.

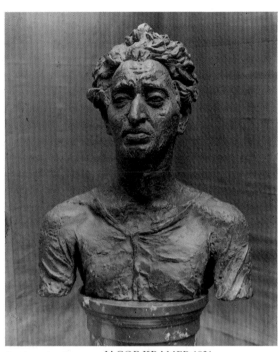

Epstein continued

JACOB KRAMER 1921
Bronze
635 x 533 x 254 N03849
In 1920 Epstein wrote to Kramer, the Leeds painter, 'Are you thinking of coming to London soon? I have been lately pondering a new large work & if you are still in the mood to sit for me, I wish you would. You could be of immense use to me & I hope you will give me an opportunity to make a study of you...I hope you will come soon because I feel full of my idea & am eager to get at it.' This large work was to have been a *'Deposition,'* for which Epstein was considering using Kramer for St. John, with Mary Magdalen. It was never realised, but Epstein was nevertheless enthused by modelling from Kramer, who 'seemed to be on fire... Energy seemed to leap into his hair as he sat...'. Kramer was one of three models who had posed for the first Christ, the 'Risen Christ' of 1917-19.

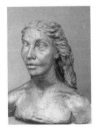

KATHLEEN 1921
Bronze
470 x 470 x 305 N06089
This is the first of nine portraits of Kathleen Garman, secretary and model to Epstein, who later (in 1955) became his second wife. This head was begun the day after Epstein met her, and her rapt expression led Epstein to call this head 'Joan of Arc'.

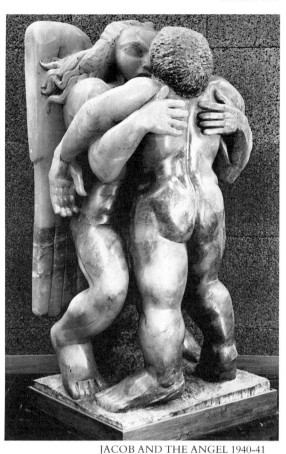

JACOB AND THE ANGEL 1940-41
Alabaster
2130 x 1090 x 1170
Granada Television Ltd

Epstein started carving 'Jacob and the Angel' in 1940, and exhibited it at the Leicester Galleries in 1942. It found no buyer, and was for a time consigned to Louis Tussaud's sideshow in Blackpool – evidence of the voyeuristic fashion in which Epstein's carvings were treated. After this enormous carving, Epstein again turned back to working in bronze. The theme is a classic one for artists, who have tended to use it as an expression of their own fight with matter – mind grappling with, and attempting to master, matter. In Epstein's case the sheer weight of the alabaster block shows particularly clearly the artist's struggle with his material. It is a struggle made all the fiercer by the artist's love for and dependence on his medium. The love-hate mix is brought out in two sketches Epstein did for the work, which show the erotic nature of the fight, and the eventual coupling of 'Jacob and the Angel'.

ERIC GILL
1882–1940

Gill was born in Brighton, the son of a vicar. He studied at the Central School of Arts and Crafts under Lethaby and Edward Johnston, who taught him lettering. He was a member of the Art Workers' Guild, and of the Fabian Society 1905-8. He became a Roman Catholic in 1913, and entered the Order of St Dominic as a tertiary in 1918. In these years he was engaged on carving the 'Stations of the Cross' in Westminster Cathedral. While he was living at Ditchling in Sussex (1907-24), he ran a private printing press. He later retreated further into the country – to Capel-y-Ffin in Wales, and finally settled in Pigotts, Buckinghamshire. Gill designed two important and much-used typefaces: Gill Sans and Perpetua.

ALPHABETS & NUMERALS, ALPHABET 1909

Hoptonwood stone

619 x 330 x 60 / 479 x 330 x 60 / 324 x 429 x 79 T03733-T03735

These three inscribed alphabets were carved for reproduction in the portfolio by Edward Johnston, *Manuscript and Inscription Letters for Schools and Classes and for the use of Craftsmen.* Johnston had previously used Gill for the section on 'Inscriptions on Stone' in his 1906 book *Writing and Illuminating and Lettering.* This was because Johnston was a letterer on paper rather than a carver. Gill had recommended using Hoptonwood stone and slate as the best materials for inscriptions that were to be placed out of doors. The alphabets on display were reproduced as separate plates so that students could copy them more easily.

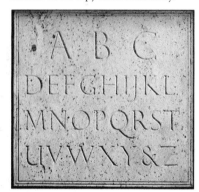

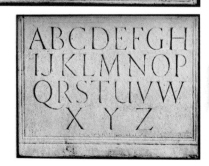

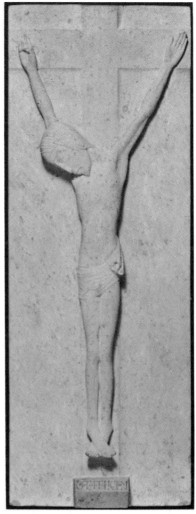

CRUCIFIX c.1913

Hoptonwood stone

452 x 171 x 41 T03736

After his conversion Gill carved several crucifixions and small crucifixes. He had previously, before his conversion, executed a 'Crucifixion' (1910) which is also in the Tate collection. All such works by Gill reveal the highly personal tone of his religion, which was not bound by conventional restriction, and in particular, used the themes of love and sex without embarassment.

CHRIST CHILD 1922

Painted wood

140 x 340 x 13 T03449

Written under the base of this carving is 'Original carving made by Eric Gill to decorate a baby's crib'. It was made to decorate the Christmas crib in the chapel at Ditchling.

23

Gill continued

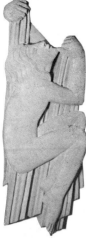

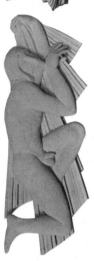

EAST WIND & NORTH WIND 1928-9

Portland stone

254 x 705 x 102 / 260 x 698 x 111

N04487/T03737

In 1928 Gill had led a team of five sculptors on a project for the facade of the London Underground Headquarters building in Broadway, Westminster. Charles Holden, the architect, was responsible for this and other audacious projects of collaboration between architects and young sculptors. The project was loosely based on the historical Tower of the Winds in Athens, and each of the five sculptors (Aummonier, Gerrard, Moore, Rabinovich and Wyon) carved one wind, while Gill carved three. The two carvings presently on display are reduced copies of two of these. He made the copies in the autumn after the building was finished, and immediately exhibited them in the Goupil Gallery. He had been unhappy with the speed at which he had had to execute the architectural sculpture (in under three months) and the low priority put on it by the builders. The copies may have been an attempt to salvage his designs for himself, and to make them more visible to the public. As a contemporary critic observed, 'Eric Gill is charming and chaste, with a carving technique of the greatest refinement, not quite suitable for outdoor wear and at such a height'.

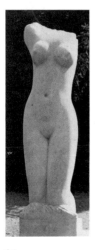

MANKIND 1927-8

Hoptonwood stone

2413 x 610 x 457 N05388

In 1928 Gill wrote in a letter, 'For the big figure I carved in that big lump of Hoptonwood which I had & never used at Ditchling I'm getting £800... Eric Kennington is buying it. Anyway it's a success one way & another & we can breathe freely for a bit'. The money helped Gill to buy Pigotts. Kennington the sculptor, owned the piece for ten years, and, after Whipsnade Zoo had refused to accept it, he sold it to the Tate for a greatly reduced price. As it had lost its polish from being exposed outdoors, it was repolished in 1957. On this occasion, Kennington wrote, 'If I did not tell you you wouldn't know that I personally regret the polishing of Mankind... Opinion will be divided. Sculptors I guess on my side. It could not be better done. But we do love the STONE.' For Gill, whose carvings are generally frontal, 'Mankind' is unusually three dimensional.

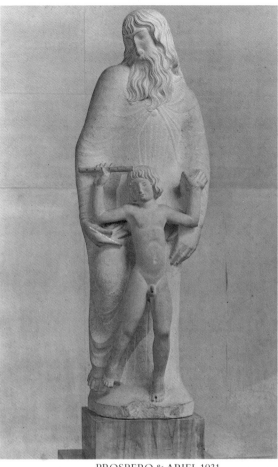

PROSPERO & ARIEL 1931
Caen stone
1270 x 457 x 356 N04808

This is a model one third of the size of the group above the entrance of Broadcasting House, which Gill had done through the agency of Herbert Read. After preparatory drawings, the carving was completed over four months. The B.B.C. had set the subject, and neither it, nor the end result greatly pleased Gill, who wrote, 'I don't much like looking at (it). The idea was grand but I was incapable of carrying it out adequately. Prospero and Ariel! Well, you think. The Tempest and romance and Shakespeare and all that stuff. Very clever of the B.B.C. to hit on the idea, Ariel and aerial. Ha! Ha! And the B.B.C. kidding itself, in the approved manner of all big organisations, that it represents all that is good and noble...'. In fact Gill adapted the subject personally, seeing it as God the Father sending forth the Word, and added, 'For even if that were not Shakespeare's meaning it ought to be the B.B.C.'s.'

HENRI GAUDIER-BRZESKA
1891–1915

Gaudier was born near Orleans in France. In Paris, beginning as a sculptor, he met the Pole Sophie Brzeska, with whom he shared a name and lived thereafter. In 1911 they settled in London, and although living in extreme poverty, associated with some of the most important of avant-garde writers and artists in the Bloomsbury and Vorticist circles. Ezra Pound was particularly important to Gaudier, both in shaping criticism of his work, and in assuring his posthumous fame with his biography of him. Gaudier was a founding member of the London Group exhibiting society, and signed the Vorticist manifesto in the first issue of their magazine Blast. *He enlisted in the French Army in 1914, and was killed the following year.*

RED STONE DANCER c1913
Red Mansfield Stone, polished and waxed.
432 x 229 x 229 N04515

This was one of five sculptures which Gaudier exhibited at Roger Fry's Grafton Group exhibition in 1914. Gaudier apparently likened the sculpture to the poetry of Ezra Pound, who wrote of this piece, 'The abstract of mathematical bareness of the triangle and circle are fully incarnate, made flesh, full of vitality and energy. The whole form-series ends, passes into stages with the circular base or platform.' Pound's theoretical base to his poetry – Imagism – was an important stimulus for Vorticism. He soon began to link his stipulations for poetry with those for the visual arts. 'There is a sort of poetry where music, sheer melody, seems as if it were just bursting into speech. There is another sort of poetry where painting or sculpture just seems as if it were "just coming over into speech"'. Pound admired compressed images, where a lot of information is stored very simply, and loved ideograms and Chinese calligrams. He saw Gaudier's images in this way, and probably encouraged Gaudier to look at oriental art.

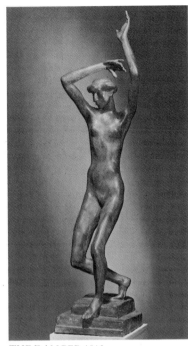

THE DANCER 1913

Bronze

775 x 178 x 197 T00762

This is one of three casts made at the Fiorini Foundry, London in 1965 from the original plaster which is now housed at the Tate. There are also three other bronze casts in existence, two of which were made before 1918.

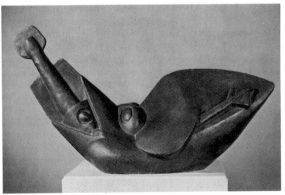

BIRD SWALLOWING A FISH
c.1913-14

Bronze

318 x 603 x 279 T00658

This work is sometimes known as 'The Sea Bird'. Gaudier had made a plaster, and one or two bronzes were made in Miss Brzeska's lifetime. Six bronzes were made in 1964 from the original plaster; one of these went to Henry Moore, and another to the Tate Gallery.

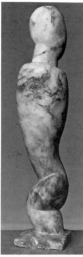

Gaudier-Brzeska
continued

THE IMP c.1914
(on display from January 1989)
Veined alabaster
406 x 89 x 83 N04516
Pound described this as a 'late work,
grotesque'.

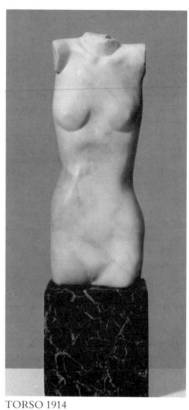

TORSO 1914
Grey veined marble on a base of Tinos marble
356 x 102 x 76 T03731
Sophie Brzeska offered 'Torso' to the
Victoria and Albert Museum in 1915.
Torso may have been a riposte to the
sculptor's critics who were offended at his
primitivistic modernism, but it also
answered authentic artistic desires on the
part of Gaudier. 'I long to make a statue of
a single body, an absolute, truthful copy –
something so true that it will live when it
is made even as the model himself lives',
he wrote in 1911, and was proud that
'Torso' revealed his skill as a sculptor.
Gaudier made drawings from life, from
the painter Nina Hamnett, and used these
for the sculpture. Two casts have been
made from this marble.

The 1920s saw a very fluid period in English sculpture: there were many brands of modernism, and it did not come to be definitely restricted to any one kind of sculpture or group of artists until the end of the decade and the crystallization of a group around the critic Herbert Read, including, most notably, Henry Moore and Barbara Hepworth. Before this, artists as diverse as Epstein, Dobson, Kennington, Skeaping and Under-wood were all very much seen as modern.

One criterion for modernist sculpture common to the periods before and after the war was the practice of direct carving. It was now becoming more entrenched, and accepted as a *sine qua non* by even conservative critics. Carving was used as the identification mark for modern sculptors. This meant that Kineton Parkes, in his 1921 book, *Sculptors of To-Day,* identified among the 'English Independents', lesser known artists such as Stirling Lee, Walker and Ernest Cole, primarily because they carved the stone directly. Parkes placed them among artists represented in this display: Gill, Dobson, Jagger and Epstein. He partnered Epstein with Ernest Cole as 'the rebel sculptors of London', principally because of their architectural sculpture.

A decade later Parkes wrote a book solely devoted to *The Art of Carved Sculpture,* and in it we encounter Kennington, Underwood, Barbara Hepworth and her husband John Skeaping, Moore and Epstein (from this display) alongside other, less famous, names.

Parkes sets off with his definition of modelling as a 'building-up of form, a synthetic process of detail added to detail, direct carving is a cutting down, an analysis made from

the composite factors of the mass of the material', and this distinction between an additive and a subtractive process is the most basic one to our understanding. Another catchword for Parkes, again associated with direct carving, is 'glyptic'. Although 'glyptic' means no more than 'relating to engraving or carving, especially on precious stones', it takes on qualitative associations in contemporary discussion. Of Kennington he explained:

'This passion of feeling for expression is partly responsible for his adherence to carving. He feels that he must convey directly in his material the glyptic image which his inner vision has seen. In modelling he can do this and has done it, but the necessities of work in stone have led him to express himself in stone better than in clay; he has to go all the way with his conception, and has been rewarded for his courage by his success.'

Similarly with Underwood Parkes asserts the superiority of carving as a technique:

'He was so disappointed with the results of the casting of these that he resolved on cutting direct. The failure of the bronze he attributes to the successive changes in relief-emphasis due to the casting in plaster from the clay and then from the plaster to the bronze casting. In these mechanical processes he saw his original purpose disappearing.'

Now, Parkes reports, Underwood is 'a true adherent of the direct-carving school, and he goes all the way. He does not employ any kind of model, but attacks at once the stone, with perhaps some slight drawing only as a memorandum, or certain guide-marks in pencil.'

Women sculptors were notable among the direct carvers, and also tended to be animaliers, or sculptors of animals.

However, another sculptor who was highly regarded in the twenties and thirties, Frank Dobson, was not only a carver, and certainly was not

concerned about direct carving, for he was quite happy to employ assistants as intermediaries. Like Epstein, Dobson denied that there was any essential distinction between carving and modelling. What was important was dealing with material three dimensionally. Unlike Epstein, Dobson retained the same style whether he carved or modelled. Dobson is essentially a sculptor in the round, and Gill essentially a sculptor in relief.

Dobson was unusual in working from the life, and in sequence form, building up from drawings to clay models and maquettes. Eric Underwood, in his 1933 book *English Sculpture,* contrasted Dobson and Gill on all these points, and added:

'Dobson and Gill provide an interesting contrast in their sources of inspiration. Gill's art is, in its essence, Christian: it reaches back through Romanesque to Byzantine, whereas Dobson's is pagan, deriving by way of the French from the Greeks of the sixth century B.C.'

Gill was, however, with Epstein and Dobson, seen by Underwood as 'the three best-known sculptors working in England today'. Dobson was, and has sometimes been, devalued as a mere English Maillol; Epstein was frequently regarded as exotic, if not simply Jewish; whereas Gill's art was seen to embody a particularly English tradition. There was a strong contemporary tendency to 'explain' artists by national traditions, and Dobson can certainly be fitted into the context of post-war French neo-classicism which used the female nude to express ideas of peace and plenty.

Kineton Parkes entitled his next chapter 'The Form Sense: The Young Englishmen', and this betrays the search for new words to describe this new kind of sculpture which was going beyond straight-forward realism. It was also going beyond direct-carving, for, although much of it was in fact carved directly, it had something more in terms of shape

31

and form that also had to be described. In these years Roger Fry's phrase 'significant form' was frequently used to guarantee the value of work that otherwise escaped conventional description. By using 'significant form', artists were attempting to express deeper, more generalised meaning that could not be conveyed by naturalism. At the end of the decade another French movement – Surrealism – began to penetrate English art and to provide it with a new vocabulary for painting and sculpture which attempted to 'go below the surface'. Abstraction and Surrealism have tended to be polarised, but as artists such as Moore and McWilliam realised, their art could be all the stronger for combining the two approaches, which were not anyway, as far as they were concerned, separable. McWilliam has explained,

'Before the war there was a tendency to take sides. The young sculptor was either Surrealist or abstract, but now that we've explored both ideas, it's possible to take a wider view without being intolerant one way or another.'

Among Parkes' young 'Englishmen' were Maurice Lambert, Barbara Hepworth and her husband John Skeaping, and Henry Moore. Although his wife's fame has since vastly superseded Skeaping's, in the late twenties Skeaping was very much in the vanguard of modernism. His technical superiority in terms of carving and his knowledge of stone assured his influence.

Skeaping's love of exotic, rare, and frequently very hard stones worked first as an inspirational challenge, but always ran the risk of developing into a fetish pursued for its own sake.

Parkes admired Moore's first one-man show at the Warren Gallery, and identified him as pursuing the question of 'significant line'. He invoked Gaudier-Brzeska's animal sculptures as the nearest parallel, and

indeed all three artists, Hepworth, Skeaping and Moore, exploited the talisman-like animal form as if afraid to push their formal and technical experimentation on to the human figure.

Kineton Parkes' enthusiasm sometimes displays a certain underlying nervousness:

'I do not deny a measure of sincerity to artists such as Moore and the Skeapings, but I do not allow that apparently designed distortion which disfigures their examples of their form-sense. Elephantiasis is no virtue either in Nature or in Art.'

Epstein's 'Genesis' proved a difficult testing ground; Parkes began by rejecting its shocking association: 'There is no reason for the distortion and really un-necessary ugliness', and yet ended with: 'it is a triumph of pure form... an evocation of beauty of form founded upon a noble inspiration.'

Parkes' modernism had triumphed over his conventional expectations, and many people experienced similar sea-changes in this period. Form began to be appreciated for its own sake, and for the generalised but deep-seated emotions which it could evoke. Exact likeness, noble message or classical tale were no longer expected from a sculpture. With the encouragement of a few critics, increased knowledge of African and oriental art, and the way opened up by the pre-war sculptors, the public (though still a small one) began to accept and to appreciate a new kind of form. English modernism was (albeit briefly) assured.

CHARLES SARGEANT JAGGER
1885-1934

Jagger was born in Sheffield, and began work there as a goldsmith. He later trained at the Royal College of Art, and, still very much in a 19th century mode, was influenced by Alfred Gilbert and Rodin. As an ordinary soldier-sculptor (having served in the war) he was an obvious and popular choice for war memorials. It has been suggested that the huge demand for war memorials in Britain (as in France) retarded all the artistic advance made before the war. On the other hand, it is interesting to see how the experience of working on a large scale, and often in stone, refines and modernizes Jagger's aesthetic. The most famous of Jagger's memorials is at Hyde Park Corner, London, but the first was a commission received from Hoylake and West Kirby, and shows well his increasingly simple architectural approach to monumental art. This formal shift was doubtless connected to his own wartime experience, and Jagger is rep- resentative of the contemporary move away from the heroicizing of war.

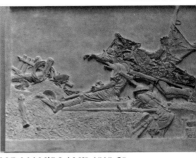

NO MAN'S LAND 1919-20
Bronze relief
1270 x 3302 N01354

Jagger began a sketch for this, in plasticine and other materials, as he was convalescing from a serious wound he had sustained in the war. It was taken from his visual souvenir of the battlefield: 'I have several ideas taken from actual battle experience, some of which are already landmarks in the history of the Empire, which I would like to have the opportunity of recording in clay', he wrote in 1918, and this relief is one of them. It is much more horrific than any of Jagger's public sculptures. The original full-sized plaster model included an inscription from Brice-Miller:

'O. little mighty band that stood for England
That with your bodies for a living shield
Guarded her slow awakening.'

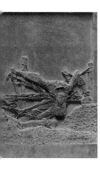

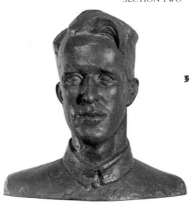

ERIC KENNINGTON
1888-1960

Kennington was also a sculptor of war memorials, also saw active service, and was an Official War Artist 1916-19. However, viewed as a whole, his career as an artist is much less dominated by the war as a theme than Jagger's, although it is true that he was again a War Artist in 1940-45.

He was the son of a painter, and painted himself, specialising in portraiture.

Kineton Parkes wrote, 'Eric Kennington sees things differently from his fellow-artists. The nearest approach to his vision is that of some old Indian painters; it, like theirs, sees decoratively; ... His is a sculptor's vision with all the precision of three dimensional form.'

HEAD OF T. E. LAWRENCE 1926
Bronze
413 x 425 x 254 N05438

Kennington had gone to Arabia in 1920 to illustrate Lawrence's *Seven Pillars of Wisdom*. This bust was modelled partly from life and partly from drawings in 1926, and chosen by Lawrence's family to go in the Crypt of St. Paul's. Kennington greatly admired Lawrence, and the latter was pleased with the bust, describing it as 'magnificent'. 'It represents not me but my top moments, those few seconds when I succeed in thinking myself right out of things.'

EARTH CHILD c.1936-7
Portland stone
1321 x 597 N05029
The model was the artist's daughter.

FRANK DOBSON
1888-1963

Dobson began painting with his father, and then studied under the sculptor Reynolds-Stephens. He made his first wood carving in 1913, but then went to serve in the war. He met Wyndham Lewis and exhibited with Group X in 1920. He had his first one-man exhibition in 1921, joined the London Group the following year, and was its President until 1927. He was increasingly part of the establishment, acting as an Official War Artist, and Professor of Sculpture at the Royal College 1946-53. His focal role in British sculpture of the twenties and thirties has only recently, in the last decade, been re-acknowledged.

THE MAN-CHILD 1921
Portland Stone
768 x 559 x 324 T01322
Dobson worked on this from many drawings he had made from life. Its original crisp outlines, which have been weathered over the years, once gave it a much sharper effect.

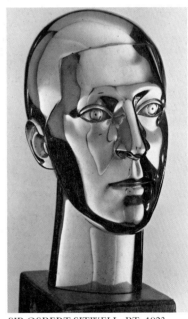

SIR OSBERT SITWELL, BT. 1923
Polished brass
318 x 178 x 229 N05938
T. E. Lawrence offered this head to the Tate Gallery, describing it as 'Appropriate, authentic and magnificent, in my eyes. I think it's his finest piece of portraiture and in addition it's as loud as the massed bands of the Guards.' It is an unusually potent example of the message being carried in the medium.

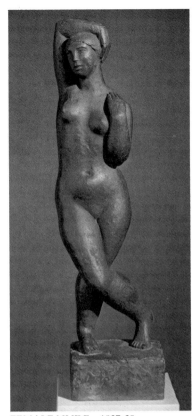

FEMALE NUDE c.1927-28
Bronze
400 x 102 x 76 T00663

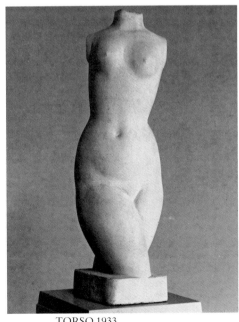

TORSO 1933
Portland stone
673 x 203 x 203 N05874

LEON UNDERWOOD
1890-1975

Underwood was a sculptor, painter, wood engraver and writer. Apart from four years on active service he was a student at various art colleges from 1907 to 1920. Instead of going to Italy when he won a prize in the Rome Scholarship competition, he went to Iceland. He started his own, very influential, and always idiosyncratic, art school in 1921. He travelled extensively, was very interested in non-Western art, and wrote several books on various aspects of it. He re-opened his drawing school in 1931 and was an important liberal contact for the rising generation. He was interested in cutting metal after roughcasting it: 'because I feel that there are sculptural possibilities in metal – inherent in it. They are pre-eminently of this age and can be expressed concretely in no other way.' He was excited by the spirit of a new age full of mechanical potential.

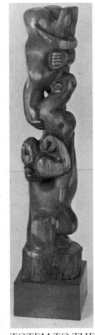

TOTEM TO THE ARTIST 1925-30
Yew
1105 x 254 x 273 T00644
Underwood carved 'Totem' from a trunk of English Yew that had been growing on Chiswick Mall in London, and had been condemned by the council. In 1964 he expressed his pleasure about being asked 'about the subject matter of my 'Totem'; no one has asked me before. In the Twenties, the old matter of belief (ie subject matter) was not wanted. Matter was supposed to be qualified by the artist as 'significant form'; but this significant was inconsistent. The figure at the top is the artist, his head identical with the heel of his creation – the middle figure by which he is elevated. His work is received by the public, the bottom figure.'

TORSO c.1923-30
Tournai Slate
473 x 203 x 108 T02324
Although inscribed 1930, this sculpture was carved in 1923, according to the artist. Underwood's early sculpture is anyway difficult to date, as he tended to work on pieces over a number of years, and also to exhibit pieces long after making them. This was first shown only in 1961.

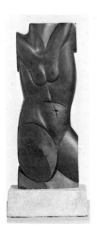

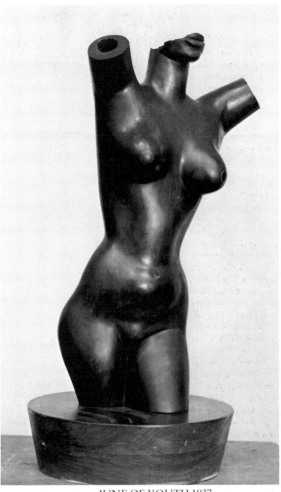

JUNE OF YOUTH 1937
Bronze
610 x 381 x 216 N04975

In the Tate's cast on display, the holes of
the truncated arms were left with a return
surface, and the breasts inlaid with silver.
Underwood had kept close to the whole
casting process. (The artist's alienation
from the casting was one of the direct
carvers' main quarrels with modelling.)
Underwood wrote, 'Metal on account of
its tensile strength, is particularly suitable
as a medium for the dynamic idea. I have
therefore made extensive experiments in
the modification of the usual bronze
casting practice, so that I am now able to
cast small works inside the studio. In
doing this the real character of the bronze
form becomes apparent; a thin skin of
metal from a twenty-fourth to a quarter
of an inch thick. When the whole process
is again in the hands of the sculptor he can
design the model to exhibit the skin
characteristic of bronze form.'

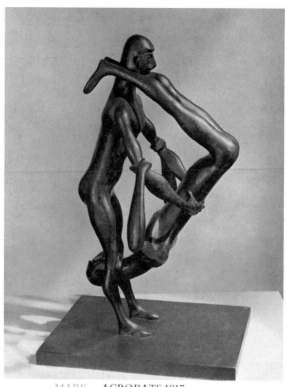

MARK
GERTLER
1891-1939

*Gertler was primarily a
painter. His Polish-
Jewish background was
a formative influence.
He studied at the Slade,
and exhibited with the
New English Art Club
from 1912 and with the
London Group from
1915. He became
intimate with
Bloomsbury circles. His
first one-man exhibition
opened at the Goupil
gallery in 1921. In
1932 he began to teach
at the Westminster
Technical College.*

ACROBATS 1917

Bronze

597 x 419 x 375 N06033

Gertler wrote to D. H. Lawrence that he
had been sculpting over the winter of
1916-17, and this piece is known to have
been finished by April 1917. Although it
is earlier in date, its syncopated rhythm,
and general mannerist, rather twisted
elongation of the limbs, suggest the
formal context of the twenties.

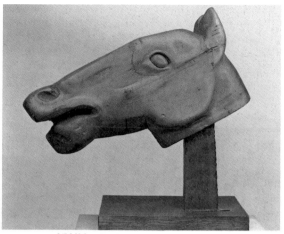

JOHN
SKEAPING
1901-1980

*Skeaping rose to an
elevated position within
the academic art
establishment, and
although he was
Professor of Sculpture at
the Royal College of
Art from 1953 to 1959
(succeeding Dobson),
and was commercially
successful as a cautious
realist sculptor of horses,
he seems to have
harboured a certain
bitterness about the way
things turned out in the
thirties. Skeaping went
from being a 'young
modern' in the eyes of
the critics and his earlier
fellow artists, to being
seen as a reactionary.
He had enjoyed early
success in the academic
ladder, winning a Rome
Scholarship in 1924.
This academic distinc-
tion did not prevent him
from being quickly
taken up as an exponent
of the newest kind of
sculpture. He was an
exhibitor at some of the
most seminal shows of
the late twenties, and his
wife, Barbara Hep-
worth, was a natural
co-exhibitor. However
he became disillusioned
with English modernism
after the focus shifted to
Moore, Hepworth and
Read, and after
Hepworth had left him.*

BLOOD HORSE 1929

White pinewood

692 x 749 x 356 N05455

This was previously catalogued simply as
'Horse's Head'. It belonged first to the
dealer Sydney Burney, and then to the
Leeds collector, Michael Sadler. Burney
exhibited it at his gallery in an exhibition
called *Sculpture considered apart from Time
and Place*. This kind of exhibition was a
typical way of oiling the 'sticky' path of
modern sculpture. By showing it next to
works from other cultures the spectator's
pre-conceptions about how sculpture
'ought' to look could perhaps be circum-
vented. At the exhibition Sadler, whose
own collection was diverse and came
from many countries and many periods,
bought pieces by Moore, Hepworth and
Zadkine. His collection had earlier served
as a source of visual stimulus to Moore.

41

**BARBARA
HEPWORTH
1903-1975**
*See biography in
next section*

FIGURE OF WOMAN 1929-30

Corsehill stone

533 x 305 x 279 T00952

This is a good example of Hepworth's style at the end of the twenties, a couple of years before she moved into fuller abstraction. Although her early abstractions were still obviously based on the human form, they are first and foremost shapes, whereas pieces such as this 'Figure', are first and foremost human beings. In the late twenties Hepworth was trying many different materials: English stones, Greek and Italian marbles, alabaster, Burmese wood, teak etc. 'Figure of a Woman' reveals the smooth rounding-off of edges which lead the viewer around the shape – a trait very characteristic of her later abstract works. It was exhibited in 1930 at Tooth's Gallery, where Hepworth and Skeaping exhibited together.

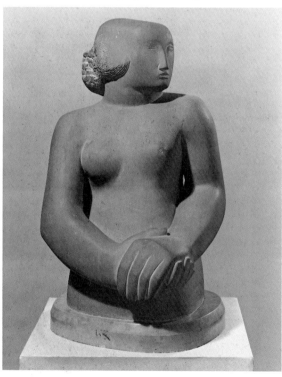

HENRY MOORE
1898-1986

*See biography in
next section*

*Moore stands to the
British Surrealists
rather as Picasso did to
the French movement.
Both had a creative
energy fertile enough to
attract Surrealist
attention, yet this very
fertility meant that they
could never be strictly
classified as 'Surrealist'.
'We claim him as one of
us', Breton had said of
Picasso. Picasso allowed
himself to be drawn into
surrealist activity to a
certain extent, and
similarly Moore
exibited at the
International
Surrealist Exhibition
in London in 1936. For
both, Surrealism must
have represented much
that was appealing
outside the artistic
establishment.
Surrealism also
provides us with a useful
tool in describing a
certain period and a
certain manner in
Moore's sculpture. Like
the Surrealists, Moore
was interested in chance
findings, and in
allowing such
unprovoked visual
stiumuli direct access to
his art. Surrealism not
only describes a formal
aspect of Moore's
sculpture, but also an
emotional one – the
disturbing associations
that his work may
invoke. Moore asserted,
'all good art has
contained both abstract
and surrealist elements.'*

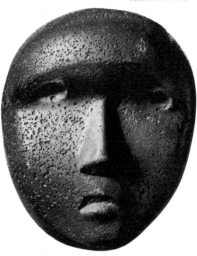

HEAD 1928
Cast concrete
200 x 180 x 130 T03762

Moore was interested in using concrete
for the resistance it offered in the process
of carving. It was also cheap and had an
interesting texture. In the 1920s Moore
was especially interested in Pre-
Columbian art, and this 'Head' suggests
some mask or ritual object. Despite their
blunt primitivism, the carvings of this
period show a bolder and more expressive
rendition of the human face than Moore's
later work. The anxiety in this head
reveals the 'surrealist' spirit that was in
fact innate in Moore.

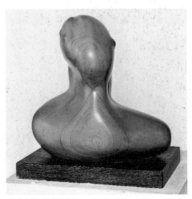

COMPOSITION 1932
African wonderstone
445 x 457 x 298 T00385

At this stage in his career, Moore was
rapidly assimilating some of the formal
elements of the work of Picasso, Arp and
Tanguy. There is a notable development
in his personalization of abstract form.

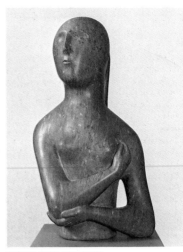

Moore continued

HALF-FIGURE 1932
(on display from January 1989)
Armenian marble
686 x 381 x 279 T00241
'Half-Figure' relates to a series executed
between 1930-32. The alertness of the
figure, its 'glance' and the way it looks out
at the spectator, thereby extending itself
into space, combine formal and emotional
vocabulary. There is a distinct surrealist
anxiety about the piece, along with
Moore's concerns for truth to his material
and a move towards softer, less primitive
figuration.

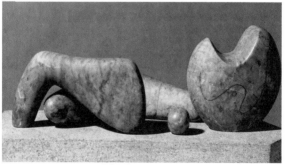

FOUR-PIECE COMPOSITION:
RECLINING FIGURE 1934
(on display from January 1989)
Alabaster with marble base
175 x 457 x 203 T02054
'Four-Piece Composition' illustrates both
the rational and the irrational forces that
Moore considered part of art. The choice
of Cumberland alabaster for its surface
polish and the way it took incised marks,
and the focal incisions themselves are
evidence of very conscious control, but
there are also, as Moore hoped there
would be, 'gaps that you can't explain,
there must always be a jump'.

F. E.
McWILLIAM
b.1909

McWilliam was born in Ireland, and studied at the Slade and in Paris 1928-32. McWilliam had his first one-man exhibition in 1939, and went on to exhibit in many of the focal shows for modern British Sculpture: Battersea Park 1948 and 1951, 40 Years of Modern Art 1948, 40,000 Years of Modern Art 1949, Festival of Britain 1951, Unknown Political Prisoner 1953, Holland Park 1954 and 1957, Sculpture in the Home 1953-54. McWilliam was seen as a Surrealist sculptor, although he later explained: 'What appealed to me in Surrealism was that it made for freedom of thinking – I was for Surrealism but not with it'

EYE, NOSE AND CHEEK 1939

(on display in the Wolfson Room 1 until March 1989)

Hoptonwood stone

889 x 870 x 286 T00871

This almost abstract work was made just after McWilliam had begun to group himself with the British Surrealists. It has surrealist overtones because of its associative qualities, but can also be enjoyed for its purity of form, thus placing it within the field of abstraction.

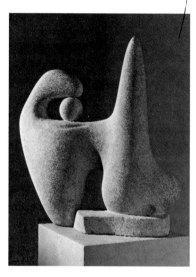

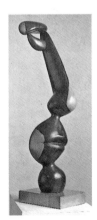

PROFILE 1940

Lignum vitae

622 x 178 T00599

The Tate purchased 'Profile' from the artist in 1963. McWilliam worked on this piece over six months from a single piece of wood. It was his last work before joining the R.A.F., thus ending a series he had exhibited in March 1939 called 'The Complete Fragment'. The sculptor wrote, 'These carvings were mostly part or parts of the head, greatly magnified and complete in themselves. They concern the play of solid and void, the solid element being the sculpture itself while the "missing" part inhabits the space around the sculpture'.

THE SCULPTOR IN HIS STUDIO
1937

Wood relief with paper collage, ink and pencil, strip brass and nails.

464 x 432 x 44 T00308

This was shown in the exhibition organised by the British Surrealist, Roland Penrose, *40,000 Years of Modern Art,* and later in the basement of the Academy Cinema during the war.

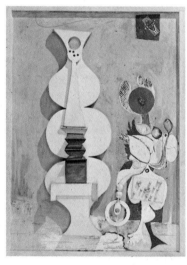

TWO FEMALES 1937-8

Painted wooden relief construction with strip brass and two brass ornaments.

1600 x 1168 x 89 T00307

Richards explained that this is an interpretation of two contrasting concepts of the female form; one virginal, the other productive or fertile, representing the 'vegetable' or sexual side. The relief is the last but one of a series of twelve begun in 1934. Hans Arp admired this among others in the artist's studio.

46

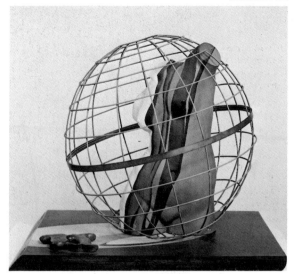

ROLAND
PENROSE
1900-84
*Penrose was influential
in transmitting ideas
current on the Continent
to Britain, notably those
of his Surrealist friends
in France such as Ernst,
Breton, Eluard, Miró,
Man Ray and Buñuel,
but also of less partisan
artists such as Picasso
and Braque. He lived in
France between 1922
and 1936; returned to
London to organize the
1936 Surrealist
exhibition, and
continued to paint and
exhibit with the
Surrealists until 1939.
As a founder and
director of the
International Institute
of Contemporary Art in
London, he was able to
draw on his extensive
contacts to launch an
important exhibition
programme. He
continued to promote
Britain's role in a wider,
European artistic world
throughout his career.*

THE LAST VOYAGE OF SIR CAPTAIN COOK 1936/67

(on display in the Wolfson Room 1 until March 1989)

Mixed media

692 x 660 x 851 T03377

This Surrealist object was first exhibited at the 1936 *International Surrealist Exhibition.* In a true surrealist spirit, Penrose put together a number of objects from very different sources. Their surprise combination, and the way in which the artist has treated them, causes the kind of disorientation in the viewer that is the seed of all surrealist art. The plaster torso came from a shop in Paris, the globe-cage was made by a London bicycle repairer, the saw handle came from Penrose's workshop. The first version of this assemblage was destroyed during the war; apart from the base which has since been found, this is the second version made by the artist and his son over thirty years later.

47

This gallery is dominated by works by Moore, Hepworth and Gabo. Although Gabo was born in Russia, and died in America, the years which he spent in England were those years when English art was suddenly internationalized, and established an equal footing with abstract movements abroad. The cohesion of the English abstract movement did not survive the war. Moore adopted more resolute figuration; Gabo left for the States. Group activity – manifestos, exhibitions, publications – ceased, and the artists worked in a much more isolated way, able to do this, no doubt, because of their rising fame.

In 1931 Herbert Read wrote, in his *The Meaning of Art,* 'We may say without exaggeration that the art of sculpture has been dead in England for four centuries; equally without exaggeration I think we may say that it is reborn in the work of Henry Moore.'

In his own book on *English Sculpture* of 1933, Underwood commented, 'this is a very remark-able statement', and wondered whe-ther the work of Dobson, Epstein and Gill should 'be dismissed as something other than sculpture?'. Read and his circle had not yet estab-lished their claim to be all that was modern as thoroughly as they were soon to do.

The critics Herbert Read and Adrian Stokes were important to Moore, Hepworth and other artists in articulating an argument for their sculpture. They provided not only the public, but also the artists themselves, with a way of talking about their work. Much of what they said, however, coincided with tenets that had been held before the war – direct carving, truth to materials, discovery of the form within the block. Nevertheless, new gener-

ations need new vocabularies, and Read provided unusually eloquent formulae. Stokes, and Read increasingly, also provided the creative process with a psychological meaning. In Read's preface to Hepworth's and Nicholson's 1932 exhibition at Tooth's we recognize the concern which we encountered at the beginning of this display:

'It is now clearly recognised that the decadence of European sculpture during the last three or four centuries has been due above all to an increasing separation between the artist and his material.'

The two directions of modern European art recognized by Moore – surrealism and abstraction – were well represented in the important 1934 exhibition of a new grouping of English artists concerned to move England into Europe: *Unit One*. Hepworth and Moore were the sculptors, Nicholson among the seven, principally surrealist painters, and they were joined by two architects. Paul Nash announced the group's formation in *The Times* in 1933. Although the two poles of abstract and surrealist art were inherent in *Unit One,* the following years saw a move towards increasing polarisation rather than fusion, and it was towards abstraction, or concrete/constructivist art that Moore and Hepworth inclined.

This movement found expression in Nicholson's purged 7 & 5 Society, Nicolete Gray's *International Abstract and Concrete Exhibition* of 1936, and the publication of *Circle* in 1937. Nicholson and Gabo were the editors, with J. L. Martin, of *Circle: International Survey of Constructive Art*. *Circle* encompassed a wider circle than strictly constructivist artists, and illustrates an increased confidence on the part of English artists and architects, their desire for international recognition, and the stimulus provided by continental refugees such as Gabo, Gropius,

49

Lubetkin, Moholy-Nagy and Mondrian. It was extremely optimistic, almost utopian in tone, and aimed to affect and reflect all aspects of life. The close association of artists with architects, and the breakdown of divisions between disciplines (eg between painting and sculpture for Nicholson, between engineering, sculpture and architecture for Gabo) is apparent at this time, and is a precedent for later interdisciplinary stimuli (eg see Sections Four and Six).

Gabo wanted to establish an approach whereby art objects could be seen as 'pure plastic objects', although he understood that the general public was used to 'searching in a work of plastic art for the familiar forms of Nature and for the literal sense of well-known every-day emotions.' As music is based on seven fundamental notes, so, he said, art should be understood to be based on fundamental forms, although these were not, however, anything more than means and material: 'it is in their totality and mutual rhythmic connection that the value and vital sense of these forms is to be found'.

In his *Realistic Manifesto*, issued in Russia in 1920, Gabo had laid the groundwork for constructivist art.

'We construct our work as the universe constructs its own, as the engineer constructs his bridges, as the mathematician his formula of the orbits.'

'We do not turn away from nature, but, on the contrary, we penetrate her more profoundly than naturalistic art ever was able to do.'

Gabo declared that constructivists would use line for its direction, not for its descriptive quality; depth, not volume; kinetic rhythms, not static rhythms; light, not colour, and would renounce, in sculpture, the mass as a sculptural element.

Moore, Hepworth and Gabo were all engaged in letting space and light into sculpture; on piercing its

previously solid monolithic form. The open sculptural form was a tremendous breakthrough, and has connections with these artists' love of landscape and working outdoors.

Abstraction was set up against Realism in the Cold War period. The lack of any specific subject matter in Moore and Hepworth's works meant that they could later be projected as the art of the free world in contradistinction to the naturalistic art of the Soviet bloc. Moore and Hepworth were extensively toured by the British Council, and cultural politics undoubtedly account in part for the tremendous status they enjoyed.

BARBARA HEPWORTH
1903–1975

With her Yorkshire compatriot, Henry Moore, and her second husband, Ben Nicholson, Barbara Hepworth became one of the central figures in the artistic movement that has become known as English Modernism. With the critical support and eloquence of Herbert Read, another Yorkshireman, this 'Yorkshire Table' (as they became known at the Royal College of Art) or 'mafia', established hegemony in the English artistic world, and retained it for a remarkably long period. From the beginning of the thirties the 7 & 5 Society moved towards complete abstraction, and it was at this point that the gentle liberties taken with animal or human

THREE FORMS 1935
Serravezza marble
200 x 533 x 343 T00696

In October 1934 Barbara Hepworth gave birth to triplets. She wrote, 'When I started carving again in November my work seemed to have changed direction… The work was more formal and all traces of naturalism had disappeared, and for some years I was absorbed in the relationships in space, in size and texture and weight, as well as in the tensions between the forms.' She was trying to discover 'some absolute essence in sculptural terms giving the quality of human relationships'.

form of the past decade
moved into the wings.
In 1933 she and
Nicholson joined the
Unit One group. With
the outbreak of war they
moved to St Ives, where
the landscape, and the
company of other
emigrant artists, notably
Gabo, proved fruitful
sources of inspiration.
She moved away from
stone towards bronze, a
move which involved,
concurrently, the use of
assistants, something
which she would never
have condoned in her
days of direct carving.
The thirties and forties
see her working on the
themes of piercing and
stringing. From 1950,
when she represented
Britain at the Venice
Biennale, she was an
increasingly
international and
established figure,
receiving a huge number
of commissions for
public sculpture.

TIDES I 1946

Hollywood with colour
337 x 632 x 298 T02008

'Tides I' is the first version of the better
known 'Tides II', which Hepworth
regarded as definitive. 'Tides II' is made
of plane wood, slightly smaller, and is
painted blue rather than white. The
splitting of the wood in this version
occurred while Hepworth was at work,
and she abandoned it. For many years it
belonged to Ben Nicholson, who gave it
to the Tate in 1975. 'Tides' belongs to a
series of oval wood carvings (including
also 'Pelagos') of the mid-forties, all
inspired by St Ives where they were
made. Hepworth's later work all relates
to the landscape, and its scale was an
important stimulus. The inter-relation-
ship between the human figure and the
landscape is frequently the source of her
sculptures, and in these years Hepworth is
'in' the landscape rather than outside,
looking on. Her responses to taking up
different positions in different kinds of
landscape were captured in the sculptures.

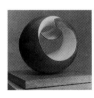

PELAGOS 1946

Wood, painted interior and strings
368 x 387 x 330 T00699

Hepworth began her oval series around
1943, once she had moved into sufficiently
spacious accommodation to be able to
sculpt. 'Pelagos' is inspired by the grand
sweep of St Ives Bay round to the God-
revy lighthouse. Although sold soon after
its completion, 'Pelagos' was important
enough to Hepworth for her to buy it
back from the previous owner in 1958.
The piercing of the sculpture – letting the
air into it – had first been used by Hep-
worth in 1931. This was in fact earlier
than Moore, but he developed its use
more immediately than she. Neverthe-
less, breaking into the form, and thereby
informing the viewer of the three-dimen-
sional nature of the piece, developed into
a central device for Hepworth. Stringing
bridges mass and void, directing the eye
as to structure, and relates of course to

Gabo (who had arrived in England in 1936), and to Moore. Hepworth wrote:

'The colour in the concavities plunged me into the depth of water, caves or shadows … The strings were the tension I felt between myself and the sea, the wind or the hills'.

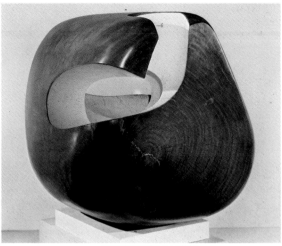

CORINTHOS 1954-5
Nigerian scented guarea wood, interior painted white
1041 x 1067 x 1016 T00531

Hepworth visited Greece and its islands in 1954, and this is one of the sculptures she did on her return, attempting to capture a 'sense of movement and interior space'. Shortly after her return the artist had received the gift of several tons of African wood, and greatly enjoyed working with it over the next decade. 'Corinthos' was the first piece she did, and it creates a tension between the obvious weight of the block, and the crisp incisions which open up the interior, creating seductive arabesque shapes and a feeling of space.

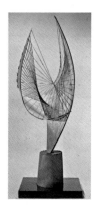

ORPHEUS (Maquette 2, version II) 1956
Brass with strings
1149 x 432 x 413 T00955

This is the third and largest of three models for a commission in Mullard House, London, called 'Theme on Electronics (Orpheus)', which was nearly four feet high. Hepworth began to make metal sculptures in the mid-fifties, and they relate to an idea of drawing in space. Orpheus shows her using cut metal sheet, and it suggests the interiors of some of her earlier carvings, almost as if stripped of their outer coverings. It is interesting that Hepworth adopted metal in the period when it was playing such a prominent part in the work of the new generation of British sculptors.

53

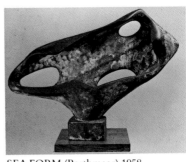

Hepworth continued

SEA FORM (Porthmeor) 1958

Bronze

768 x 1137 x 254 T00957

Porthmeor Beach is a long beach at St Ives, washed by Atlantic breakers. Hepworth had only begun to have works cast in bronze in 1956, so this is an early bronze. With these new pieces we see her released from stone and wood forms; able to make freer, frequently more elongated, shapes. She even began to cast earlier carved sculptures in bronze, moving resolutely away from her earlier adherence to the doctrine of truth to materials which had meant that a work could only be in the material in which it was conceived. Success and demand meant that direct carving was no longer practicable. Casting also meant that she had to employ assistants. She now took a much freer and less subservent attitude towards her materials, moving between them fluently, and used wood less and less.

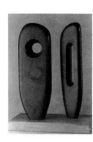

TWO FIGURES (Menhirs) 1964

Slate

756 x 635 x 330 T00703

These two forms were carved from the same piece of slate from a deep Cornish quarry. Hepworth was not aware of the fossil leaf until it appeared with the very last polishing. Like many other pieces in Hepworth's oeuvre, 'Two Figures' relates to the human form. In 1950 she had visited Venice, and became aware of the special posture and gait which people adopt in different architectural settings. 'Two Figures' obviously relates to such horizontals and verticals. It also relates, however, to an increasing sense of ritual magic in her later sculpture, and its title refers to the ancient monuments in Cornwall. Her work, whether in marble, slate or bronze, began to take on a similar surface polish, and colour became more important than any other quality intrinsic to the material.

NAUM GABO
1890-1977

Gabo was a pioneer of Constructivism, where sculpture is built up rather than carved or modelled. It involves breaking-down a given object or shape to its underlying structure or skeleton, and rebuilding it using these fundamental lines and planes. Gabo spent World War One in Norway, where he made his first constructions, beginning with simplifications of the human head and body. In 1917 he returned to the Soviet Union and became involved with avant-garde revolutionary artistic activity. He moved away from human form to geometrical forms. From Moscow he moved to Berlin, Paris, and then, between 1936 to 1946, to Britain. The rest of his life he spent in America. Cubist analysis of forms was a contemporary stimulus for him, and he was also interested in as traditional an art form as Russian icon painting. The finished effect of his first constructions is very different from the polish of his later work, as they were frequently rather clumsily put together

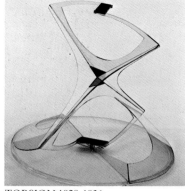

TORSION 1928-1936
Perspex
352 x 410 x 400 T02146

This work is again one version of a recurrent motif, but in this instance, the Tate owns all of the other versions. This particular version dates from the earliest years of this preoccupation with this theme, and it was not until 1968 that 'Torsion' was translated into a far larger scale. In 1929 Gabo gave his brother Antoine Pevsner permission to develop this work into a variant 'Construction in Space (Project for a Fountain)', which now belongs to the Kunstmuseum, Basle. The success of the finished piece encouraged Gabo to think of 'Torsion' in the same terms so that when, in 1968, the Director of the Tate Gallery, Sir Norman Reid, visited his studio, Gabo expressed his desire to see the sculpture built on a large scale. Reid was successful in finding a sponsor (Alistair McAlpine) and a site (outside St. Thomas's Hospital by Westminster Bridge, London) where the 'Revolving Torsion, Fountain' was erected in 1975.

from cardboard and glue. Most have been destroyed, but since reconstructed. Later work, made from glass, plastic and metal, was often conceived as architecture. The idea of

STONE WITH A COLLAR 1930-31
Stone
178 x 152 x 79 T02147

It is interesting that in line with the English reputation for landscape or nature inspired art, Gabo in England not only began to use organic shapes (crystalline structures, shells, trees), but also began to carve in stone (something he had not done since he was a student). It is not impossible that Moore and Hepworth's fondness for stone at that time encouraged him in this. This work and a smaller version in the Tate served as models for a least two larger sculptures made in 1933 where the stone form was combined with a collar of curved plastic.

sculpture as architecture was to be important again in the seventies. In America he was at last able to realise works on a monumental scale (for example the Bijenkorf Construction), and in the early fifties was Professor at the Harvard Graduate School of Architecture. In England Gabo became friendly with the Head of Research at I.C.I., John Sissons, who introduced him to early forms of Perspex which proved to be an ideal material in terms of transparency and lightness. It was also malleable, and allowed him to realise the curvaceous shapes of which he had dreamed. In the forties I.C.I. developed nylon thread, with which Gabo began to string his objects, the strings replacing the lines which Gabo had formerly incised on his pieces. Gabo also developed his spheric theme form in England – a never-ending shape which continually comes back on itself. Such continuity was at the heart of Gabo's thinking: 'Space and time are re-born to us today' he had declared as early as 1920.

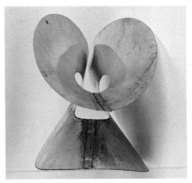

MODEL FOR SPHERIC THEME WITH CENTRE c.1937

Tinplate

102 x 76 x 83 T02174

In 1936, Gabo discovered this 'Spheric Theme' and continued to work with it well into later life. With it, he explained 'I eliminate angularity in space construction and give space the curved character which it has to my perception'. To those who associated this piece with the mathematical model for infinity, the Moebius strip, Gabo argued 'To my mind the image of infinity could not be an image which turns back on itself. I feel in this Spheric Theme continuity rather than infinity.'

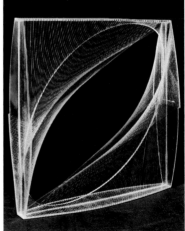

LINEAR CONSTRUCTION NO. 1 VARIATION 1942-3

Plastic with nylon threads

349 x 349 x 89 T00191

FIRST MODEL & MODEL FOR MONUMENT TO THE UNKNOWN POLITICAL PRISONER 1952

Plastic and wire-mesh

127 x 32 x 25/

381 x 89 x 95 T02186/T02187

Gabo received joint-second prize for his submission to the competition for a monument to 'The Unknown Political Prisoner' (see introduction to next section). Of the theme of the competition, Gabo observed 'The tyrant wants us to be in fear of him and the artist's task is not to perpetuate that fear rather to encourage resistance'.

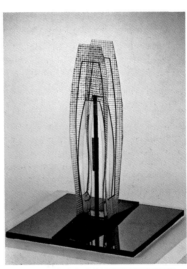

MODEL FOR A CONSTRUCTION AT THE BIJENKORF BUILDING 1955

Plastic

251 x 44 x 44 T02188

Early in 1954, Gabo was invited by Marcel Breuer (the architect of the new Bijenkorf Department Store in Rotterdam) to produce a large sculpture which would be sited on or near the new building. Within three months, Gabo had supplied Breuer with models (which the Tate also owns) for a wall relief to be extended from the second storey up to the top of the building; and these served as points of departure for this free-standing work which was finally constructed as a 25.5 metre sculpture on the chosen site in May 1957.

Gabo continued

LINEAR CONSTRUCTION NO.2
1970–71
Plastic with nylon threads
1149 x 835 x 835 T01105

This work was presented to the Tate
Gallery by Gabo in 1971 in memory of Sir
Herbert Read who had been particularly
fond of this image. Of the eight other
versions (of differing dimensions), all
(but one) incorporate a black, cut-out
shape in the centre of the piece. Gabo
explained the omission of that feature
here; 'I made it all white, without the
black inlay in the center because I felt that
in order to keep the spirit of serenity as a
memory of Herbert, no black should be in
it'. This work is reminiscent of a form for
Gabo's unrealised project for the Esso
Building in the Rockefeller Center, New
York; two constructions of this type were
to have been attached to the pivots above
the revolving doors and to have turned
with each door as it was used. This work
hangs and is slightly supported by a base
but a 'Variation Linear No.2' in the
Albright-Knox Art Gallery, Buffalo,
made from stainless steel stands solely on
its base.

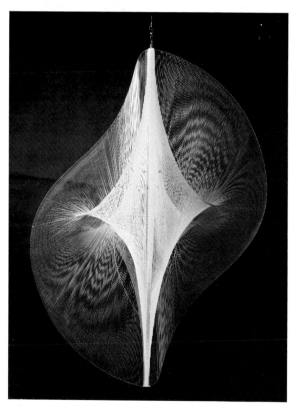

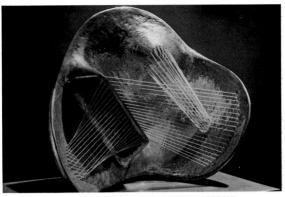

HENRY MOORE
1898-1986

Son of a Yorkshire Mining Engineer, Moore studied art at Leeds and the Royal College after briefly working as a teacher, and fighting in the war. In 1926 he became assistant tutor of sculpture at the Royal College, under the new Professor, Ernest Cole. He taught there two days a week until 1931, and during the thirties, taught at Chelsea. His first one man show was held at the Warren Gallery in 1928. He served as an official war artist 1940-42, and the 1940s saw his status established with various important public commissions. (A notable precursor to these is the work he did with Gill on the London Underground Building.) In 1948 he won the International Sculpture Prize at the 24th Venice Biennale – a confirmation of his standing. Moore was widely exhibited by the British Council, and he came to represent British sculpture abroad. His influence was also pervasive bacause he took young sculptors as assistants: Meadows, Butler, Caro, Clatworthy, Piché and King. He was for a long time a Trustee of the Tate Gallery.

STRINGED FIGURE 1938/60
Bronze/various
273 x 343 x 197 T00386

Dating from an advanced stage in Moore's association with Hepworth and Gabo, this work nonetheless represents the artist's own endeavours to discover how form might be depicted through space. In 1959, Moore rediscovered the maquette for a 'Stringed Figure' (in lignum vitae wood and string) which he had made in 1938 but had been lost by the owner during the war; Moore was happier with the maquette than he had been with the original finished piece, so decided to make an enlarged plaster copy and eleven bronzes from it.

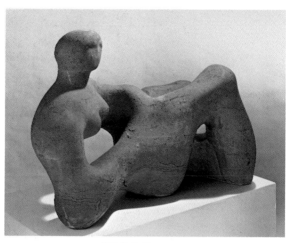

Moore continued

RECUMBENT FIGURE 1938 (On display from January 1989)
Green Hornton Stone
889 x 1327 x 737 N05387

Based on a previous work on the same scale but in wood, this 'Recumbent Figure' is the result of a commission from the architect Serge Chermayeff to produce a work for his newly-designed and built home in Sussex. Moore felt the 'Recumbent Figure' would harmonise with its long-low design, 'introduce a humanising element' and become 'a mediator between modern home and ageless land'. Moore carved this work outside his home (then in Kingston, near Canterbury, Kent), preferring the space, light and freedom found there. Almost as soon as the work was installed, Chermayeff announced his immigration to Canada and Moore agreed to keep the work in his own studio; Kenneth Clark, then a purchaser for the Contemporary Art Society immediately bought it and presented it to the Tate Gallery.

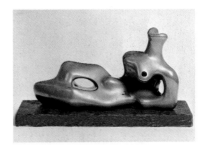

RECLINING FIGURE 1939

Lead

149 x 279 x 102 T03761

Moore's development of 'opened-out sculpture' within the reclining female form evolved in the 1930s. Moore's use of the hole is both open and closed, formal and allegorical. It is both an aperture which informs the viewer about the sculpture's shape and volume, and a hollow with sexual and landscape connotations. This sculpture is one of a series of lead reclining figures from the end of the decade. Some figures were sufficiently deep for their holes to suggest caves; others, being thinner, took on a more skeletal appearance. Although Moore continued to make reclining figures throughout his life, most of the drawings on which they were based came from this pre-war period.

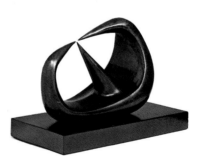

THREE POINTS 1939-40 (on display in the Wolfson Room until March 1989)

Bronze

140 x 190 x 95 T02269

With its sexual and aggressive overtones 'Three Points' shares surrealist associations with Giacometti's sculpture of the period. Although the sense of 'activity' embodied by the sculpture is broadly surrealist, it should not be linked (as surrealist source-searching tends towards) to any one source. Moore stressed that such a search would be 'a mistake.' 'Three Points' exists in three different materials: lead, cast-iron and bronze.

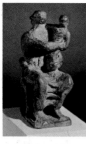

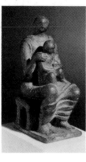

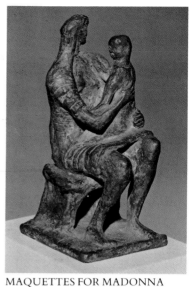

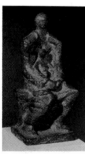

MAQUETTES FOR MADONNA AND CHILD 1943

Bronze

140 x 76 x 76/ 146 x 54 x 67/
156 x 86 x 70/ 184 x 89 x 76
N05600/N05601/N05602/N05603

This series of four bronzes are casts, selected from twelve original clay maquettes used by Moore as studies for a life-size carving of the 'Madonna and Child' in Hoptonwood stone commissioned in 1943 for the church of St. Matthew, Northampton. The Revd. Hussey, now notable for his unusually brave patronage of young sculptors, saw Moore's drawings at a War Artists' exhibition in 1942, and Kenneth Clark confirmed him in his choice. Hussey was searching for a sculpture to celebrate the 50th anniversary of his church. It took Moore five months' carving of the two ton block before it could be delivered. The local press were unsure about the piece, declaring that it 'may be beautiful in the eyes of an initiated few, but it warps a mental picture of an ideal which has remained unchanged for 2000 years.' N05602 was the maquette upon which the final piece was based; in 1949 N05603 was the model for a work of the same title for St. Peter's Church in Claydon, Suffolk. Moore wrote, 'Of the sketches and models I have done, the one chosen has I think a quiet dignity and gentleness. I have tried to give a sense of complete easiness and repose, as though the Madonna could stay in that position for ever (as being in stone, she will have to do).'

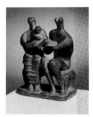

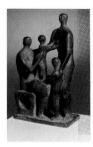

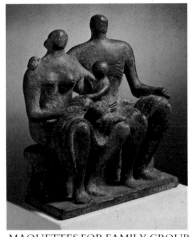

MAQUETTES FOR FAMILY GROUP
1944, 1945, 1945
Bronze
137 x 114 x 67/ 127 x 98 x 63/
178 x 102 x 60
N05604/N05605/N05606

Henry Morris, the Secretary of the
Cambridgeshire Education Authority
founded two rural colleges of education in
the county. For the second, Impington
College, designed by Gropius and
Maxwell Fry, Morris offered Moore the
commission to design a sculpture. Moore
was inspired by Morris's idealism, and
wrote, 'The Family Group in all its
different forms sprang from my
absorbing his idea of the village college –
that it should be an institution which
could provide for the family unit in all its
stages'. However, Morris failed to raise
sufficient funds, and the Cambridgeshire
councillors were anyway unimpressed by
Moore's maquette, and by his price. Two
years later the education director of
Hertfordshire used Moore's model for the
first New Town at Stevenage. Another
Impington maquette was scaled up a
decade later in Hadene stone for another
New Town, that at Harlow, near Moore's
home at Perry Green. Again the family
group was thought to be apposite for a
New Town designed for young 'settler'
families.

Moore had made fourteen original
terracotta maquettes; these three bronzes
were cast and served as models for larger
sculptures; eight were worked in stone,
one in terracotta and five in bronze.
Moore's development of the small bronze
model dates from this period; it served to
publicize his work and bring him a good
revenue. Between 1943 and 1947 140
were cast; the Tate bought five in 1945.

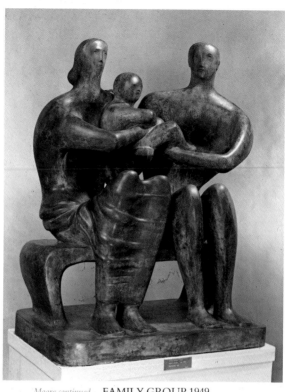

Moore continued FAMILY GROUP 1949
Bronze
1524 x 1156 x 781 N06004
For the history behind this work see
above; it derives from the maquette
which Henry Morris hoped to have scaled
up at Impington, but which was finally
used at Stevenage. It was Moore's first
opportunity to prepare a large work for
casting. His assistant Bernard Meadows
prepared the interior armature. Stevenage
paid Moore a low fee on the condition
that he could retain his right to cast the
work again; the second cast went to the
Tate Gallery.
When the first cast was placed against a
wall outside Barclay Secondary School,
Stevenage, Moore expressed some
dissatisfaction; he felt the work required
to be seen from all sides and suggested it
be mounted on a revolving plinth to allow
for some compositional variety.

ATOM PIECE (Working Model for Nuclear Energy) 1964-5 (on display from January 1989)
Bronze
1181 x 914 x 914 T02296

In 1964, the University of Chicago commissioned Moore to produce a sculpture to mark 25 years of controlled nuclear power production. Moore's response was to produce a maquette he had made some weeks earlier which closely resembles the 'Helmet Head' series he had just been working on; 'you produce better work – through it being a natural development in your own direction – than if you stop and think of something special.' Again, Moore's work was based on a hand-sized maquette (rather than a working-drawing) which he then translated into a intermediary-sized plaster model entitled 'Atom Piece (Working Model for Nuclear Energy)'. Seven bronze casts were made and Moore presented his own cast of 'Atom Piece' to the Tate Gallery in 1978. The commissioned work, 'Nuclear Energy' (1964-6) was a unique cast in bronze and stands over 3.5 metres high.

UPRIGHT FORM: KNIFE EDGE 1966
Portuguese Rosa Aurora marble
597 x 565 x 241 T01172

In 1966 when Moore was staying in his studio at Forte dei Marmi, near Quercetta, he visited a local stonemason's yard at Anralte. On seeing the square block of Rosa Aurora marble, the 'Upright Form' idea immediately suggested itself. Back in his studio, Moore set the block on one corner with the apex pointing upwards; with as few cuts as possible, he wanted to evoke the sense of one half of the form reaching down into the ground and the other half reaching up for the sky. Although happy with the purity of this form, Moore felt the 'Knife-Edge' did not work in this slightly translucent marble so he decided to carve another version in a more opaque form of white marble; this was the only occasion upon which Moore re-carved a previous theme.

BEN NICHOLSON
1894-1892

Nicholson was the son of the painter William Nicholson, and married the painter Winifred Dacre. In Paris in 1921 he saw the works of Braque and Picasso, and painted Cornish and Cumbrian landscapes which, though naturalistic, were informed by his knowledge of modern French painting. He joined the 7 & 5 Society in 1924 and became its chairman in 1926. Around 1930 he began to work and exhibit with Barbara Hepworth, who became his second wife. Together they explored abstraction; Nicholson using more geometric forms, Hepworth more curved, organic shapes. Nicholson worked in shallow depth, frequently cutting away layers in cardboard. His first all-white relief was exhibited with the 7 & 5 in 1934. Nicholson is also noted for his line drawings, frequently of architecture, and they like all his work convey a sense of space. His work is rich in variety, but always subtle and restrained. In 1932 he and Hepworth made close contact with a number of French artists, and joined the Abstraction-Création group. Nicholson moved to Cornwall in 1939, and was there for the next twenty years. He and Hepworth had separated by 1951, and Nicholson later moved to Switzerland. Like Moore and Hepworth, he enjoyed international prestige from the fifties on; representing Britain at the Venice Biennale of 1954.

SCULPTURE 1936
Wood, paint
228 x 305 x 241 T04119

This work is one of only two 'sculptures' ever produced by Nicholson (both date from around 1936; this one in wood, the other in plaster). However, much of his painting and relief-work is essentially sculptural in the nature of its enquiry. The 'interlocked' form was sawn, planed and sanded from a single block of wood, and then painted white in the manner of his contemporary white reliefs. In 1936, Nicholson was sharing a studio with Barbara Hepworth and on the verge of establishing the periodical *Circle*. This brief experimentation with sculptural form probably arose as much from his enquiry into how an 'object' becomes art, as from purely sculptural concerns.

KURT SCHWITTERS
1887-1948

Schwitters was born in Hanover, and studied in Dresden. He soon developed an idiosyncratic kind of art, built up in layers from collaged pieces, to which he gave the name 'merz'. This name came to him from an early collage in which the word 'Commerz' (from the name of a bank) was cut in two and appeared prominently on the work's surface. Although interested in using non-fine art materials such as rubbish and discarded ephemera, he never abandoned his pride in good workmanship, and an ultimate desire to make the work pleasing to the eye. Thus, though involved with the Dada movement, he could never really embrace their anti-art stand. Association with constructivist artists led him (like other Dadaists) to incorporate constructivist elements into his work, which uses geometric forms, and displays an overall balance despite the multifarious nature of its material. As his work was increasingly ridiculed in Nazi Germany, he spent more and more time in Norway. He fled to Britain during the war, where he was interned, but was at least able to continue painting. From 1945 Schwitters lived in Ambleside, where, with the aid of a grant from the Museum of Modern Art, New York, he was able to embark on the last of three large-scale, long-term constructions ('Merzbau') in a barn.

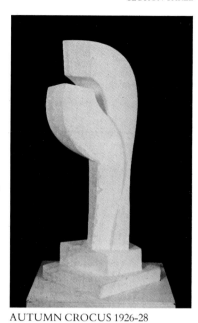

AUTUMN CROCUS 1926-28
Plaster .
810 x 293 x 293 T03766

In the mid-twenties, under the influence of the Dutch *de Stijl* movement, Schwitters began to develop his ideas about 'spiritual organism' and the forms adopted by natural structures in the process of growth (bones, crystals, plants etc). With themes such as 'fish' 'arabesque' or 'violin', his work occasionally adapted a swirling, upward arabesque form (as seen here in the stem of the 'Crocus'). 'Autumn Crocus' is one of Schwitters' freshest images and perfectly expresses his fascination with the process of 'Nasci' ('to come into being').

The light, white, abstract purity of the St Ives group did not survive the war. Moore and Hepworth were of course still very much alive, and increasingly lionised, but it was not only that new initiatives came from younger sculptors, but also that they themselves began to use metal, and returned to a much more figurative idiom. For a time they had led sculpture away from the traditional monolithic vertical which implicity betokened the human figure. This move – so simple and yet so significant – was short lived. After the war sculptors returned to the figure. Nevertheless, although using the upright vertical figure form, these sculptors did not necessarily return to the closed form. They explored the open sculpture of their predecessors, and found other materials and techniques with which to develop ideas about the extension of sculpture. Calder's earlier visits to Britain had publicised his use of similar new materials.

An important exhibition, at which a new group and style were seen to coalesce, was the British Pavilion at the Venice Biennale of 1952. The sculptors who exhibited there were Robert Adams, Kenneth Armitage, Reg Butler, Lynn Chadwick, Geoffrey Clarke, Bernard Meadows, Eduardo Paolozzi and William Turnbull. Henry Moore was represented by one sculpture outside the Pavilion. Inside were the younger generation – all born between 1913 and 1924.

Herbert Read wrote a short introduction in the catalogue, agreeing that these artists had learnt from Moore, but adding that they were not his imitators. Read was becoming increasingly interested in the idea of art almost unwittingly bearing witness to the inner subconscious, and it was the war that he saw

manifested in the 'creative will' of these sculptors. His words have become famous:

'These new images belong to the iconography of despair, or of defiance; and the more innocent the artist, the more effectively he transmits the collective guilt. Here are the images of flight, or ragged claws "scuttling across the floors of silent seas", of excoriated flesh, frustrated sex, the geometry of fear.'

There was a more positive side to his introduction: 'these British sculptors have given sculpture what it never had before our time – a linear, cursive quality.' Read pointed out that they avoided monumentality; he did not add that they avoided the head. Not only was the body waiflike, it was also topped with a pinhead. The flatness of the body may well have been a reaction to Moore's sensual roundness. A later sculptor, Philip King, affirmed the sense of Read's interpretation:

'The sculpture ... was terribly dominated by a post-war feeling which seemed very distorted and contorted. Then you had Germaine Richier and the brutalist sculpture of the time. And

it was somehow terribly like scratching your own wounds, an international style with everyone showing the same neuroses.'

(King was, however, describing an exhibition of 1960). Tucker also saw the post-war sculpture as using 'cheap and melodramatic imagery'. Certainly it moved away from the formal concerns and generalised iconography of the St Ives group, towards a newly subjectivised sculpture, but in doing this, the sculptors were nevertheless introducing new approaches to material. The oxyacetylene torch permitted new ways of working, while Butler also explored hand-forging – taking the 'direct' method of working to metal. Butler had come to sculpture through architecture and ironwork, and this

absence of formal art school training was a characteristic shared by several of these sculptors. Several were also painters and painting influenced their sculptural forms. In studies of the early modern French sculptors, it has frequently been asserted that it was the painters who broke sculptural boundaries, and perhaps this may have been somewhat the case in Britain in the fifties.

The fifties also saw the first concerted attempts to give sculptors a place on the street and in the lives of most people. The open-air sculpture shows in Battersea and then Holland Park were indicative of this concern, and the Festival of Britain of 1951 commissioned a sizeable number of sculptors to enliven the South Bank Festival Site in London. Although the sculptors in these shows tended to be from the older generation, what was important was the public role given to sculpture. London County Council organized the shows in the parks, and from 1956 they also spent £20,000 a year on sculpture for housing estates and schools. The Arts Council, the British Council and the I.C.A., along with the boards of the New Towns (notably Harlow), Education Authorities (notably Hertfordshire), and even commercial firms promoted sculpture to such an extent that they seemed to consider it to be THE post-war art.

A prime example of the new status accorded sculpture, and its public presence, was the competition for a monument to the Unknown Political Prisoner of 1952. This was an internationally organized exhibition intending to commemorate the unknown victim of the second world war – a symbolic generalization intended to reach the understanding of all countries. The twelve sculptors who got through the British 'semi-final' were Trevor Bates, Butler, Chadwick, Frink, Hepworth, Louise Hutchinson, Stuart Osborne, Eduardo Paolozzi, Douglas Wain Hobson, J. L. Waldron, F. E. McWilliam and Arthur W. Wyllie. Others among the commended were Clarke, Turnbull

and Underwood. The organizer, Anthony Kloman, set forth the following statement in his introduction to the exhibition at the ICA: 'Sculpture is the art in which great themes have been traditionally expressed ... Believing that our modern age has themes worthy of such monumental celebration, and that modern sculptors have already shown a promise of being equal to such a challenge, this competition was planned on the following comprehensive lines.

A theme was chosen because a theme is inherent in the whole idea of memorial sculpture. But a theme is no limitation on style and the organizers emphasized that a symbolic or a non-representational treatment of the subject would receive the same consideration as a more naturalistic treatment.'

Abstraction was thus condoned, but in practice, total geometric abstraction was not seen fit to portray the subject. The strength of this period's belief in the subject is asserted by the very decision to hold a competition for a monument; a decade later this would have been impossible. By then sculpture had returned to formal concerns; monumental now meant only big, not commemorative. As it was, the monumental scale of the project rather mis-fired in 1953. The public, confronted with 57 tiny models at the I.C.A. often seemed unaware of the fact that these were to be massively enlarged. Instead, they complained that the scale was derisive. Butler won the International competition, but even at this late stage, the project again proved ill-conceived; Butler's model was never erected.

'Britain's new iron age' was the title Lawrence Alloway gave to an article he wrote in 1953 in which he discussed sculptors in this display: Butler, Chadwick, Paolozzi, Turnbull, Clarke and Armitage.

REG
BUTLER
1913-1981

*Between 1941 and 1945
Butler trained as a
Blacksmith, and he
made his first iron
sculpture in 1948. He
became assistant to
Moore in 1947. He had
previously trained and
practised as an architect,
and did not in fact give
up his practice until he
was nominated first
Gregory Fellow in
Sculpture at Leeds
University (the next
were Armitage and
Dalwood). E. C.
Gregory is another
example of the support
given modern British
sculpture by
Yorkshiremen; he had
helped Moore as far
back as 1923. Butler
had a retrospective at the
1954 Venice Biennale.
Butler did not only
make semi-abstract
spindly metal
constructions, he also
worked from the female
nude. These nudes later
took on a radically
different appearance to
earlier work – full, fat,
rounded, explicitly
(often grotesquely)
sexual – they were made
in bronze and painted
pink.*

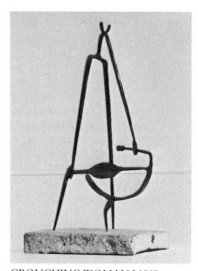

CROUCHING WOMAN I 1948
Forged and welded iron
190 x 498 x 89 T03711

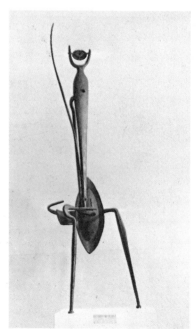

WOMAN 1949
Forged iron
2210 x 711 x 483 N05942
This was one of the sculptures exhibited
in the seminal exhibition at the Venice
Biennale in 1952, and was his first
important large piece. A smaller
maquette, just over 12 inches high, has
recently been acquired by the Tate.

STUDY FOR WOMAN RESTING
1950
Bronze wire
127 x 349 x 127 T00263
This is one of the studies for 'Woman Resting' in the Aberdeen Art Gallery, which is over five feet long, and made from forged and welded iron. It was a commission for the Festival of Britain, and exhibited at one of the regional exhibitions, in Glasgow.

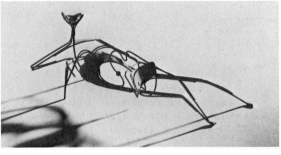

GIRL 1953-4
Bronze
1778 x 406 x 241 N06223
Butler wrote that "'Girl' is the first full-size "volume" sculpture executed by me since 1948... before the iron figures 1948-51'.

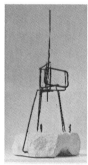

FINAL MAQUETTE FOR 'THE UNKNOWN POLITICAL PRISONER' 1951-52
Bronze sheet and wire, with stone base
445 x 205 x 165 L01102
The semi-final for the International Sculpture Competition, *The Unknown Political Prisoner,* was held in the New Burlington Galleries in January 1953. The 140 international finalists were exhibited in the Tate the following March. Butler won the Grand Prize, runners-up included Gabo, Hepworth and Pevsner, while conpensatory prizes were awarded to Calder and Chadwick, among others. The maquettes exhibited were all under 18" high, but related to very large monuments – in Butler's case, 300-400 feet high. The scrap metal used by Butler incited a Hungarian refugee to damage the maquette the day after the exhibition opened. Butler stated: 'I have very great sympathy for anyone who felt that a little bronze wire sculpture eighteen inches high was, to put it mildly, a slight way of commemorating the ten million victims of the gas chambers and concentration camps …'. This maquette is one of two replicas made by Butler from the damaged original. The base is the piece of

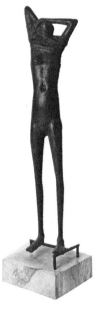

73

gravestone from which the plaster base of the original had been cast. Butler related the shape (just as his critics did) to the radio and radar towers positioned on the south coast cliffs during the war. Their presence was all the more alluring because these cliffs were forbidden to the usual holidaymakers for over six years. Butler worked on the projects for iron monuments before the Political Prisoner competition had been announced. A breakthrough occurred in his work for the project when, in 1952, he arrived at the figure looking up – a form which he used extensively from then on. The Tate also owns Butler's 'Working Model', made in response to the wish of certain influential Germans to see the monument erected in West Berlin, and which is over four times larger than earlier maquettes. Negotiations in West Berlin meandered on without success for over a decade, and were finally laid to rest in 1968.

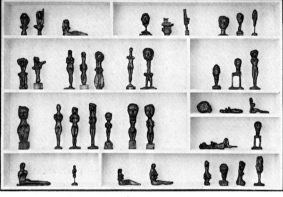

MUSÉE IMAGINAIRE 1963
Bronze in wooden display cabinet
800 x 1232 x 112 T03703

This cabinet contains thirty-nine figures of various heights, all made by Reg Butler. The title, 'Imaginary Museum', comes from the contemporary French writer André Malraux who used it to describe the world of art now available to everyone through illustrations and reproductions of works of art. He also used the phrase 'Museum without Walls' to describe this phenomenon.

LYNN
CHADWICK
b.1914

Chadwick began working as an architect and furniture designer. After his war service as a pilot in the Fleet Air Arm, he began to construct mobiles from metal and glass. He held his first one-man exhibition in 1950. He was commissioned to do three works for the Festival of Britain, and exhibited in the exhibitions in the London parks. In 1955 he was one of five British artists represented in the 'New Decade' exhibition at the Museum of Modern Art, New York, and the following year took the prestigious International Sculpture Prize in Venice. During the sixties his work became more block-like and monumental ('balanced sculptures' as Chadwick called them); more suitable for the many outdoor commissions which he was winning. His work continues to be based on the human figure, which he frequently presents as a couple, walking in the wind.

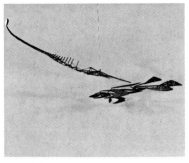

DRAGONFLY 1951

Iron

L. 2946 N06035

This was made as a model for a large work to be presented to the Tate by the Contemporary Art Society, but the Trustees decided to take it in its present form.

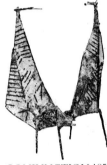

CONJUNCTION 1953

Wrought iron and composition

419 x 298 x 200 T03712

After working on mobiles for five or six years, Chadwick began to make standing sculptures using a new technique. He filled a cage of welded iron rods with stolit – a mixture of plaster and powdered iron – and filed away excess material. The powdered iron rusts and lends its colour to the sculpture. 'Conjunction' was one of the first sculptures made in this technique, and is also one of the first human couple sculptures. The mobiles had derived from animal and insect forms, as was common with many of the early fifties iron sculptors. Chadwick subsequently made a series of 'Conjunctions', the next dating from the following year.

WINGED FIGURES 1955

Bronze

559 x 432 x 356 T00416

In 1955 Chadwick produced a number of dancing figures. The present group is a maquette for a later, much larger composition of stationary figures now in Brussels.

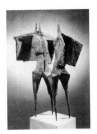

75

BERNARD MEADOWS
b.1915

Meadows worked as an assistant to Henry Moore, between studying art at Norwich and the Royal College. Moore and Meadows formed a particularly close and lasting relationship. His study at the Royal College was interrupted by his war service, when, in the R.A.F., he spent some time on the Cocos Islands, whence he derived the crab motif used in many of his works. His first one-man exhibition was in 1957. He taught at Bath, at Chelsea 1948-60, and was Professor of Sculpture at the R.C.A. from 1960. In 1954 he was commissioned by the Hertfordshire Education Committee to execute a bronze sculpture for one of its new schools, and by the T.U.C. to execute a large group for its new headquarters.

BLACK CRAB 1952
Bronze
425 x 340 x 241 T03409

There are eight casts, and one artist's cast, of this work. 'Black Crab' (unlike other works) is not modelled on any one crab species, but is, in Meadow's words, 'the distillation of crabness'. It was cast by the lost wax process at Fiorini's Foundry in London, and Meadows was involved in the casting. At the same time he was making some of the waxes for Moore's bronzes. In his 1953 article Alloway reasoned, 'To justify the openness of form in their sculpture, artists have turned to non-human sources: insects, with their extensive legs, antennae, wings and long thin bodies being particularly convenient … Bernard Meadows uses crabs and cocks …' Drawing is an important part of Meadows' process – working out sculptural solutions in pencil and wash.

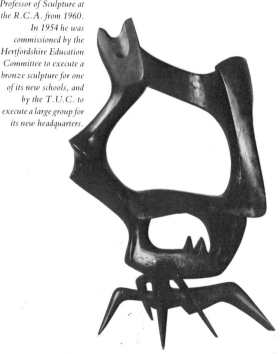

KENNETH ARMITAGE
b.1916

Armitage was born in Leeds, where he began studying art, subsequently moving on to the Slade. He served in the Army 1939-46, and then taught at Bath School of Art until 1956. He was a Gregory Fellow back at Leeds 1953-55. His first exhibition in 1952 saw the beginning of an international reputation; he represented Britain at the Venice Biennale of 1968 with William Scott and Stanley Hayter, and won the award for the best sculptor under 45. In the mid-40s Armitage destroyed his pre-war carvings, and began to model in plaster around an armature. These were then cast in bronze. From the 50s his figures became less personal, and after 1969 his technique changed, as he began to combine sculpture and drawing in figures of wood, plaster and paper. The idea of a 'geometry of fear' fits Armitage poorly; his work has a playful quality which, indeed, he saw himself as capturing 'in an attitude of pleasure'

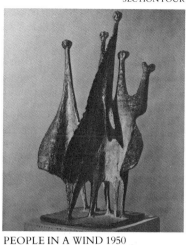

PEOPLE IN A WIND 1950
Bronze
648 x 400 x 343 T00366

This took its inspiration from life (Armitage made a sketch from a window in his house), and was modelled at the same time as he had become interested by plants with long stalks bending in the wind, and the structure of the folding-screen in his studio. Armitage was interested in weight being carried by seemingly fragile supports. 'People in a Wind' was exhibited in Venice in 1952 and an edition bought by Peggy Guggenheim. An early work, it is one of the first in which the artist developed the style later characteristic of him. Speaking more generally on a television programme, Armitage said: 'We live in a world of verticals and horizontals … Although it is mainly for movement it is also for this reason that I like sometimes to make my figures, my sculpture, on a slant, so that they run across this rather rigid pattern'. Making this sculpture at the time of an architectural summer school, Armitage was inspired by the company of architects:

'… it was my first close contact with architects and it helped partly to clarify why I had abandoned stone-carving a year or two before (that being the general interest in my student days before the war) – traditional architecture being gravity building – stone upon stone: the new being structural where the frame supported the fabric. Everyone knows this simple fact but it was not until I understood this as a principle made possible by new materials. Seeing a year or two before the Clifton Suspension Bridge, Bristol, was already an awakening experience for me. I never returned to carving.'

ROBERT ADAMS
b.1917

Adams is a sculptor, lithographer and designer. His early artistic training was haphazard as he was obliged to work part-time. His first one-man exhibition was in 1947. After being influenced by Henry Moore, he became more interested (like many in this period) by Brancusi and Gonzalez. He began working in wood and stone, and from the mid fifties, moved on into metal and reinforced concrete. Adams taught sculpture 1949-60 at the Central School. He executed several outdoor commissions for schools, ships, a theatre and for the Festival of Britain; and his relief style was extremely appropriate to such decorative work.

Adams found like-minded artists in the constructivist group around Hill and Martin (whose work can be seen in the next gallery) and if one is looking for groupings, he fits more neatly into this group in terms of allegiance.

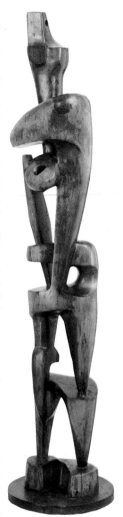

FIGURE 1949 and 1951
Yew
1000 x 230 x 230 T03866

The yew is cut from a single piece, and was accidentally damaged in 1951. At the head of the figure there used to be an extension of the horizontal shape that curved back in a semi-circle, and this was broken off. Adams then decided to alter the conception of the figure by re-cutting the top which in fact made the whole figure more acceptable to him as a more abstract shape. In 1949 Adams was working in plaster, cement and stone as well as wood. Another figure in Bath stone uses rod and disk shapes similar to those in the Tate's figure. Later in the same year Adams made his first sculptures in metal.

JOHN HOSKIN
b.1921

Hoskin worked in a drawing office until he joined the army 1942-47, which, perhaps unusually, he found a usefully formative period. When he returned to work in the drawing office he found that he could not tolerate it, and, taking odd-jobs, began to paint. He worked through reliefs and constructions to 'sculpture proper'. In 1956 he began to weld and work in iron. Hoskin worked as an assistant to Chadwick. In 1958 he began work on a large commission for a Bristol church which helped to sort out technical problems, and led him to use sheet steel. Hoskin taught at Bath Academy, and later at Leicester Polytechnic.

BLACK BEETLE 1957
Welded iron wire
171 x 171 x 340 T03752

WILLIAM TURNBULL
b.1922

See biography in next section

HORSE 1954
Bronze, Rosewood and stone
1130 x 718 x 270 T01381

Around 1953 Turnbull reacted against his earlier works' concern with movement and space, and became preoccupied instead by stasis. Turnbull was interested in taking works 'out of time', and his interest in other cultures (old and new – anything other than fine art) lends an archaic feel to 'Horse'. The simplicity of the blocks of wood and stone do not suggest conventional bases or pedestals. Similarly, the rough surface of the sculpture (made by pressing corrugated paper direct into soft plaster) denies it a fine finish and suggests age. Like Paolozzi and Richard Hamilton, Turnbull was interested in the idea of 'contemporary archaeology' – imparting to his work the sense of alienation in time and geography that we feel with objects dug up from ancient cultures. The 'horse' subject only emerged as he was making it, and the superiority of process over subject matter was important to Turnbull. The emergence of an object also has parallels with the idea of suddenly finding an object on an archaeological dig.

EDUARDO
PAOLOZZI
b.1924

*Paolozzi was born in
Edinburgh; he is not
merely a sculptor in
metal, but also a
draughtsman, lithog-
rapher and designer.
His celebrity of recent
years, and his many
public commissions,
threaten to conceal the
radical and marginal
way in which he began
as an artist. After art
school study, Paolozzi
served in the Pioneer
Corps 1943-4. He
spent the last years of the
decade in Paris, where
he encountered
Giacometti and Dubuf-
fet. His involvement in
the 1952 Venice
Biennale links him more
concretely to the artists
mentioned earlier.
Paolozzi taught textile
design at Central School
1949-55, and sculpture
at St Martin's from
1955, and ceramics at
the Royal College. As
early as 1951 he was
commissioned to make
fountains for the
Festival of Britain,
while his most-seen
recent public commission
must be the one for
mosaic decoration in
Tottenham Court Road
underground station in
London. (See also next
section for more work by
Paolozzi).
Paolozzi (with
Turnbull) represents a
significant artistic
movement that is not
well represented in this
display. His work of the
late fifties, with its ugly
appearance and popular
subject matter, reflects
new interests in the
French art brut
movement and
Dubuffet, and in
popular culture,
advertising, and the
American dream world.
As early as 1951 this
interest was consolidated
in an exhibition entitled
Today we collect*

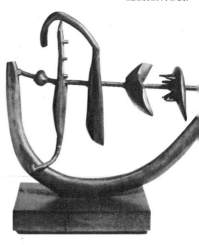

FORMS ON A BOW 1949
Cast brass
483 x 635 x 216 T00227
The plaster of this work was shown at the
I.C.A. in 1950–51, and the Contemporary
Art Society commissioned the cast,
which was done in sections, which were
then welded together.

Ads. The breadth of interests of the members of The Artists' International Association, many of whom were architects, is a significant characteristic of the group. They were concerned to bring new subjects to art, and to assert that art could be part of a wider world. Design, architecture, science and entertainment were all encompassed. Once again, the British avant-garde was engaged in an attempt to escape British provincialism. Their interests involved looking at a world outside Britain, and especially outside its continuing war-time economy. Many of these interests were pursued in a magpie like acquisitive manner. The work Paolozzi exhibited at the 1956 This is Tomorrow *exhibition at the Whitechapel, heralded the Pop Art of the next decade.*

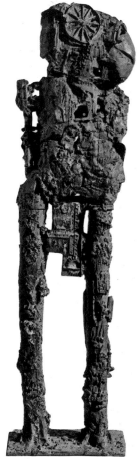

CYCLOPS 1957
Bronze
1111 x 305 x 203 T00225

In 1961 Paolozzi described his styles:
'The past: pressing objects into a clay bed, pouring wax, making diagrams, chart of events, objects in bronze from the art founders. Collage from silk-screened papers.

The present: wooden shapes cast in gun metal by engineer's foundries. Assembled like ships by bolt and weld. Photo-lithos fabricated from collage of different things: catalogues, newspapers, technical illustrations.'

We see the decisive move from traditional fine art procedures towards the industrial, technical and functional world. The messiness of the surface of 'Cyclops' is a deliberate attempt to refuse traditional polished finish; it was a radical statement somewhat lost to our own eyes, accustomed as they are to seeing extremely roughly assembled art.

GEOFFREY CLARKE
b.1924

Clarke is another artist skilled in various media: stained glass, mosaics, engraving, and metal sculpture. Clarke studied at Preston and Manchester schools of art, served in the R.A.F., and continued studying at Lancaster and the Royal College. He was unusual among the 'new iron age' sculptors in doing religious work, and did a considerable amount of varied work on Coventry Cathedral, as well as work for those of Chichester and Lincoln. His work (frequently reliefs, wall cladding, and gates) has fitted well into architectural niches, and he has therefore received many commissions, both public and private, for colleges, banks, theatres and ships. Clarke was one of the first sculptors in England to apply the welded technique which he learned on a course at the British Oxygen Company at the same time as Lynn Chadwick. He began using lead and iron, moving on to aluminium. In 1958 he installed an aluminium foundry in the grounds of his studio in Suffolk. He taught at Colchester, and became Head of the Department of Light Transmission and Projection at the R.C.A..

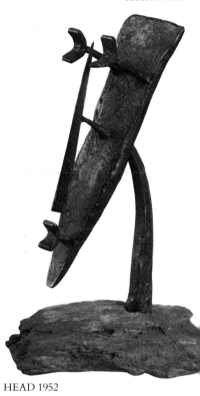

HEAD 1952
Forged iron on stone base

180 x 90 x 110 T03713

Clarke made many small forged iron sculptures between 1951 and 1955 in a shed with a forge inside (of which he was given exclusive use) near the Royal College. Many of these were heads or masks, and in some the head was laid horizontally, as if it were a stand or altar with objects on it. This head is unusual in being set into a stone base. In 1985 Clarke described this 'Head' as 'one of my favourites' and its technique as: 'Oxyacetylene cut, heat it, belt it, weld it. Then form weld (roots of stalks for instance). Heat, oil (linseed) and with a carburizing flame blacken. Flame until dry not burnt'.

ANTHONY CARO
b.1924
See biography section seven

WOMAN WAKING UP 1955

Bronze
267 x 679 x 349 T00264

This is an example of Caro's early work which has been overshadowed by his much more famous work of the sixties, to which its expressionism stands in marked contrast. It is the first and most realistic version of a theme which he went on to develop with 'Woman on her Bed' and 'My Vegetable Lover'. The original figure belonged to E. C. Gregory, and the Tate purchased a lead cast which they exhibited in 1959. At the artist's request, this was soon replaced by a bronze cast, one of an edition of six. Another of the six belonged to Henry Moore. Caro described his work of the late fifties thus, 'In my late figures the image was beginning to disappear. I felt that the figure was getting in the way. Also I think I was enjoying the clay too much – it was beginning to take charge'. 'Women Waking Up' illustrates this enjoyment of the clay, which he was later to counteract by using new materials.

BRYAN KNEALE
b.1930

Kneale was born on the Isle of Man, studied painting there and at the Royal Academy Schools, won a Rome Scholarship, and spent two years in Italy. He only took up sculpture in 1959, and his brother-in-law, an engineer, taught him to weld. He made up for lost time in the rapidity of his output, most notably after 1964. Kneale expressed the love-hate relationship engendered by working directly in metal: the directness implied intimacy, but working with metal involved weight, coldness, noise, vicious qualities and iron filings. Kneale might be seen to fit between two generations of sculptors, and this was clear in 1965 at the time of the two sculpture exhibitions, one at the Tate, one at the Whitechapel; respectively older and younger generations. Kneale was prophetic in the way that he dealt with gravity, placing the true weight of the sculpture at many different heights to avoid the sculpture always emerging from the floor. He capitalised on, and illuminated the property of steel, which is 'to be heavy but to be sustained by its own weight.' 'By distributing weight in this way I am able to escape from base sculpture.'

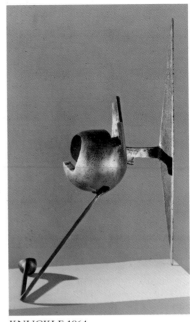

KNUCKLE 1964
Steel
851 x 641 x 305 T00695

The artist wrote, "Knuckle' evolved after my work had become less to do with actual physical joints between the various elements (joints capable of movement) and more of a way of expressing a type of energy. In other words to join disparate forms and spaces by a kind of heart or core of movement.'

ELISABETH FRINK
b.1930

Frink studied at Guildford and Chelsea under Meadows and Willi Soukop. She began exhibiting at an early age; from her first exhibition in a London gallery in 1952. She received commissions for work in Harlow New Town, Coventry and Liverpool cathedrals. Frink has taught at Chelsea, St Martin's and the Royal College. She has become part of the English artistic establishment, continuing to work in bronze, and with naturalistic human, bird or animal subjects. She began to receive renewed attention in the early eighties, with a catalogue raisonné and a large retrospective at the Royal Academy.

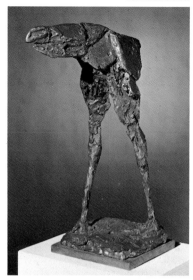

HARBINGER BIRD IV 1960
Bronze
483 x 213 x 356 T00580

This is the last of a series done during 1960. She had done two previous bird series; the first most concerned with surface texture, the next more abstract. The 'Harbinger' series were composed of 'much more slab-like solid forms' and set the pattern for the way in which Frink worked over the next few years.

IN MEMORIAM I 1981
Bronze
1276 x 1099 x 679 T03416

Frink has been making series of heads since 1959, and from the late sixties they have been used to reflect the artist's dislike of aggression and longing for peace. The 'Tribute Heads' of 1975 honoured those who had died for their beliefs, and reflect a constancy in the artist who had begun her career with a maquette for the Monument to the Unknown Political Prisoner. The 'In Memoriam' heads have the same theme as the 'Tribute' heads, and in particular refer to the work of Amnesty International. Their eyes are now open (unlike the 'Tribute' series) and in both series the heads are thinner than in those of the sixties; the 'Soldier's' and' 'Goggled Heads'.

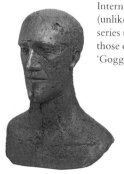

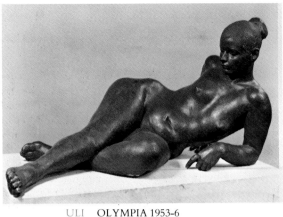

ULI NIMPTSCH
1897-1977

Nimptsch is rather different from the rest of the sculptors not only in this room, but in the whole display. Nimptsch was born in Berlin and studied there. He lived in Rome and Paris, and only settled in London in 1940. He was part of the immigrant group living in Hampstead, and his sculpture shares a central European aesthetic with other artists who use the human figure as their 'touchstone' to represent grand human emotions. Nimptsch was 'European' in an era when the British tended to look to America for all that was 'modern' in art. It is the painters of this group (eg Kossoff, Auerbach, Bomberg, Creffield and Oxlade) who have become better known to us, and who have succeeded in establishing a recognized school of painting in this country.

OLYMPIA 1953-6

Bronze

584 x 1105 x 610 T00097

'Olympia' is neither decorative, nor architectural. The human figure is used as the vehicle (and is indeed seen as the only feasible vehicle) for the artist's feelings about the human condition.

The three sculptors in this section form a bridge between the last gallery, and this one, in which Anthony Caro is the best-known figure. Turnbull and Paolozzi, in as much as that they exhibited at the 1952 Venice Biennale, could be associated with the 'geometry of fear' or iron sculptors, and Dalwood has something of this in his early work. Turnbull and Dalwood can at first be linked by their common interest in totemic, 'magic', objects, but both moved on to become engaged with some of the central sculptural concerns of the sixties. Both worked around the issues of the use of the floor, and sculpture as architecture, but despite its common concerns, their work never looked like that of the sculptors around Caro.

'Caro's things never interested me,' wrote Dalwood. 'They are very much concerned with the manipulation of formal things and the whole ethos of that work is that it doesn't regard things. It makes its own world completely without relationship to any other. And this, by definition really, doesn't interest me.' Dalwood never escaped the content of his sculpture which, through all its formal complexity, led ultimately to allegorical ends.

To group Dalwood and Turnbull together simply because they stood apart from Caro is insufficient, but their transitional work at the turn of the decade can at least be looked at before we move on to the more legitimate grouping made up by Caro and his students. Caro's dominance in the sixties, and his austere purist line made it difficult to discuss sculptors such as Dalwood in terms other than those of eccentricity.

HUBERT DALWOOD
1924-1976

Dalwood was an apprentice engineer to the Bristol Aeroplane Company 1940-44, and served in the Royal Navy 1944-46. He studied at Bath Academy under Kenneth Armitage and William Scott. Scott's painting was influential just as that of Terry Frost and Alan Davie was to be in Leeds. Armitage and Dalwood began to model at the same time; the former in plaster, the latter in clay. Dalwood became the third Gregory Fellow of Sculpture at Leeds. His first important out-door commission came from Liverpool University, for whom he made three large columns, and in the same year, 1959, he won the John Moores exhibition. Other commissions were dominated by work for universities. He won the David E. Bright Prize for younger sculptors at Venice in 1962, where he represented Britain with Ceri Richards and Robert Adams. He worked mainly in bronze and aluminium, and was probably, in 1958-9, the first sculptor to use the latter. After his sojourn in Illinois, Dalwood emerged, in 1966, with a new kind of sculpture: huge, shiny, aluminium, columnar, architectural. The Illinois grain elevators had become temples, and Dalwood had become a constructor. By 1972 he was making whole room installations from timber and cardboard. He taught at several art schools, notably Hornsey, and in 1974 was made Head of the Sculpture Department at Central.

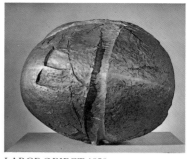

LARGE OBJECT 1959
Aluminium
762 x 889 x 889 T00323

Many of Dalwood's sculptures have the quality of a 'poetic object'; they suggest ancient ritual use, some kind of forgotten function or religious purpose. They promote, although modestly, their own importance. Dalwood wanted to give sculpture 'a more direct relevance to people's lives'. The first cast of 'Large Object' won Dalwood his prize at the John Moores exhibition, and the third cast was included in the 1960 Battersea Park *Sculpture in the Open Air*.

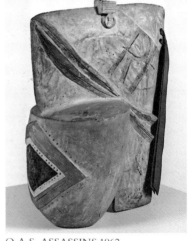

O.A.S. ASSASSINS 1962
Painted aluminium and ribbon
765 x 508 x 340 T03475

The title refers to the Organisation de l'Armée Secrete (Organisation of the Secret Army), a right-wing group in France opposed to de Gaulle's policy in Algeria. R.F. on the crest stands for République Française, or French Republic. Dalwood visited Paris for Yves Klein's wedding in 1962, and his stay coincided with the eruption of the Algerian crisis. Apart from a few sculptures of 1962-3, political overtones are rare in Dalwood's work.

WILLIAM TURNBULL
b.1922

Turnbull was born in Dundee. He served as a pilot in the R.A.F. 1941-6, studied at the Slade, and in Paris. He had his first exhibition of sculpture in 1950; of paintings in 1952. Turnbull was represented in the British Pavilion in Venice, 1952. From 1952 to 1961 Turnbull taught experimental design as a visiting artist at the Central School of Arts and Crafts, and from 1964 to 1972 taught sculpture there. He is married to the sculptor and printmaker Kim Lim. Turnbull was one of the first British painters to be influenced by American Colour Field painting. His early sculpture was semi-figurative, but by the mid-sixties he had begun totem-like abstracts. Turnbull later used painted steel geometric forms, frequently repetitive, and with no fixed order in their arrangement.

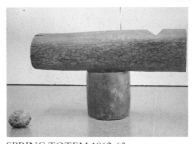

SPRING TOTEM 1962-63
Bronze and rosewood
895 x 1480 x 432 T01383

This work is not fixed, and its elements can be displayed in different ways. Although Turnbull's totemic sculptures of 1958-62 are highly idiosyncratic, they do nevertheless display some of the dominant concerns of sculpture in the sixties. They stand directly on the floor, they use contrasting materials treated differently, but generally minimally, they are moveable and changeable, and are obviously derived from and inspired by the material in an un-premeditated way.

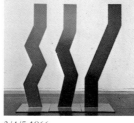

3/4/5 1966
Steel, painted red and tangerine
2546 x 2626 x 787 T01388

The title refers to the number of changes of direction in each upright. Unusually, here, Turnbull has used more than one colour, aiming to assert that the three elements are separate units.

TRESTLE 1971
Canadian pine
1048 x 1219 x 1524 T01788

'Trestle' was made by a carpenter to Turnbull's specifications, and finished and waxed by himself. He had made another 'Trestle' sculpture in 1969-70 from steel. The eight elements in this work can be placed in whatever way the installer chooses; Turnbull's insistence on permutation and variation, since the 1940s, was precocious. The trestle is part of the artist's standard studio furniture, conventionally used to support things of different status. A table gets round the conventionality of the pedestal and lays it open to question.

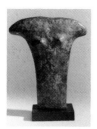

Turnbull continued

AXE-HEAD TORSO 1979
Bronze
333 x 302 x 67 T03271

In the early seventies Turnbull ceased producing sculpture, and when he began again in c.1976, he adopted a very small scale. He worked in clay for the first time, and to achieve casting with the minimum of distance between the artist's original and the bronze cast, he cast directly from the clay without the interposition of plaster. Like his work of the fifties, these pieces have a strong surface interest; whereas the earlier pieces were cast from plaster originals, these transpose the impression of the artist's handling of the clay. Mark-making is paramount, and Turnbull originally intended these objects to be handled rather than displayed. This knowledge heightens the impression of these objects as museum objects; fragments from the past, weathered, repeatedly handled, valued. As the series got larger however, a different display solution had to be found. Turnbull's emerging interest in volume over the eighties is pre-shadowed here. The relationship between head and torso carried in this piece affirms the ability of the fragment to represent the whole.

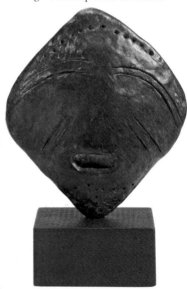

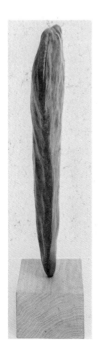

TRAGIC MASK 1979
Bronze
162 x 149 x 41 T03272

METAMORPHOSIS 2 1980
Bronze
400 x 413 x 48 T03270

EDUARDO
PAOLOZZI
b.1924

*See biography in
preceding section*

MECHANIKS BENCH 1963

Aluminium

1765 x 1838 x 483 T01469

'Mechaniks Bench' is another among the sculptures of these years seeking a way round the problem of the pedestal. In avoiding the pedestal, disguising it, or bluntly asserting it, its role can be highlighted and re-assessed. By the beginning of the sixties Paolozzi was interested in the anonymity behind the object. By using found pieces he was able to promote his concern for 'the suppression of talent'. In Hamburg between 1960 and 1962 Paolozzi became interested in the engineering forms scattered around the docks, and he was anyway already attracted to the idea of the engineer replacing the artist. Paolozzi promoted as a positive virtue his new-found distance from the making of these assembled pieces, which were put together in a factory-like situation by a team of craftsmen. The group of basic elements laid out here on the bench were used in other sculptures. In a surrealist manner, Paolozzi was transforming the found object, 'resolving anonymous materials into … a poetic idea'. The pieces on the bench are in part castings from authentic standard parts, and in part castings from forms designed by Paolozzi, and in 1972 he described it as 'a dialogue between what you CAN fabricate and what you can't, which you must therefore cast'.

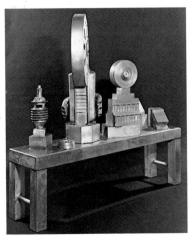

From its beginnings in Revolutionary Russia, through its development by *de Stijl* and the Bauhaus, constructivism had always had a strong sense of ideology and utopianism. In Britain it has a slightly different flavour, but some of the utopian ideology survives. Strong female participation is another notable element in British constructivism. We have already seen Constructivism in British Sculpture, when it emerged in the thirties with the group around Hepworth, Nicholson and Gabo, and with the publication *Circle*. As we have also seen, it did not survive the war. Its spirit reemerged, however, in the fifties and sixties, and we see the formation of a small but remarkably coherent group working, if not in the shadow of, then at least at a remove from the more celebrated sculptural movements of the time. We might see this movement as Constructivism Mark II, and as another attempt to internationalize British art.

A new impetus had been given Constructivist art by the publication in 1948 of Charles Biederman's *Art as the Evolution of Visual Knowledge* in America. Biederman's constructivism could be styled more correctly as concrete art, which concentrates on reliefs and constructions from which the factor of illusion has been abolished. Biederman argued that as photography had taken over the job of recording the world, artists should devote themselves to invention. As invention has no recourse to illusion, illusionism could now be shed.

Constructivism in England began in an unexpected way around 1948. Victor Pasmore, a painter by then aged forty, suddenly abandoned painting realistic scenes of London, and turned to abstraction. It was post-war America – in terms of its intellectual interests in and publi-

cations about modern European art – that gave him the impetus. He became aware that 'the war had put the clock back' and that

'...advances made in the thirties by Moore, Nicholson, Hepworth and others had stopped in their tracks and a totally provincial attitude prevailed.'

'After the war, therefore, my concern was more with getting back on the rails than with making new extensions'. He developed from abstract painting in 1948, to geometric reliefs in 1951, assembled from sheets of plywood, metal and plastic. Around him, at the Camberwell and Central Schools of Art, he gathered sculptor Robert Adams, and the painters Kenneth and Mary Martin, Adrian Heath and Anthony Hill. After a flurry of constructivist activity, the group exhibited in the summer of 1951. They also issued *Broadsheet* which illustrated their art and its principles. After other modest, essentially private, exhibitions in 1952 and 53, they exhibited again with two new recruits: John Ernest and Stephen Gilbert. Their exhibiting life together culminated at the *This is Tomorrow* exhibition of 1956 where they collaborated with architects to create total environments.

Although Pasmore and Hill corresponded with Biederman (as Gillian Wise did later), there were some important differences between the American and the English, including some which were unknown to them at the time. As they only saw his work in monochrome reproductions until 1962, they did not realise that he used strong colours, to which they were opposed. The English used mathematical systems which took them beyond abstraction from the natural world into the creation of concrete works deriving from man-made systems.

The constructivist artists had several opportunities to collaborate

with architects and work on a large scale, for even if their work was not widely appreciated, it adapted very well to architectural needs. A last collaborative effort was that for the temporary buildings which housed the 1961 Congress of the International Union of Architects. Heath and Adams had already liberated their work from strict constructivism, but its principles were maintained by the Martins, Hill, and the younger artists now becoming interested. Their continuing commitment was recorded in the magazine *Structure,* edited by the Dutch artist Joost Baljeu, which ran from 1958 to 1964. Hill and Kenneth Martin were regular contributors alongside Baljeu and Biederman.

Gillian Wise, two students of the Martins, Peter Lowe and Colin Jones, Malcolm Hughes and Jean Spencer came together as a new group of constructivists – the Systems Group – when Jeffrey Steele organized an exhibition in Helsinki in 1969. They looked not only to Britain, but also to the Swiss artists Max Bill and Richard Lohse. This is the end of Constructivism as a group-activity, but it has continued to find many individual followers, and is a potent and and unassailable part of modern art theory and practice.

KENNETH MARTIN
1905-1984

Martin worked as a graphic illustrator, and studied at Sheffield School of Art and at the R.C.A. In the thirties his naturalistic paintings associated him with the Euston Road School, but they became increasingly and then, in 1949, entirely abstract. He exhibited with the Artists' International Association from 1934 and with the London Group from 1936. In his Broadsheet No 1 *he concisely reformulated the concerns of the pre-war Russian Constructivists. After embarking on abstraction, Martin stated, 'I began to realise what I'd been missing … That I'd really missed out on the whole of the modern movement'.*

SMALL SCREW MOBILE 1953
Brass and steel
635 x 229 T00552

The artist made his first two mobiles in 1951 from rectangles of tin hung from wooden rods, and then made others from wire loops and coloured metal discs. He recognized three series: the 'reflector', 'screw' and 'link' series. The 'screw' series was begun in 1953, the 'link' after it. The present piece is one of the first screw mobiles Martin made, 'starting from simplest materials and elementary kinetic principles'. The kinetic was central to Martin who asserted, 'My work is kinetic, whether the result is still or moving.' The screw mobiles developed into the sixties. The placing of their brass strips was based on a mathematical system such as the Fibonacci series: 1,1,2,3,5,8 … Such a mobile hung in the centre of the Mary Martin-John Weeks pavilion in *This is Tomorrow*. Martin likened his process to that of Matisse, both moving (whether through abstraction or construction) towards an expressive end.

SEVENTEEN LINES 1959-63
Oil on board
1524 x 914 T00751

Martin wrote, 'Number of lines with their points of departure from and arrival at edge of painting fixed arbitrarily at the beginning. Colour sequence based on a number rhythm. Character of lines then began to act on one another and continued to do so until the last time I worked on the painting'. 'Colour identity was given to each line by a number rhythm moving forwards and backwards across the canvas. To the coloured lines was then given an added attribute, yellows tended to push across in one direction, blues in the opposite, black remained relatively still as did green … my interest in monotony and change – in movement. In the 'Screw mobiles' I draw with the metal in three dimensional space. The rapport between the reality of the element and the reality of the whole and the will of the artist is something to which I give a great

Martin continued deal of consideration'. 'All my works are governed by laws such as the one that if one thing changes so must something else, either in conformity or in opposition. Construction is the act of making in which thinking and feeling are also constructed.'

ROTARY RINGS (Fourth Version) 1968
Mobile in brass
933 x 584 x 584 T01276
This mobile is again about movement, regarded as a sequence of separate events. Martin ordered basic movements (translations, twists, rotations) using basic forms (lines and circles) made from readily available mass-produced materials. The 'Rotary Rings' continue the ideas which had developed out of the 'Screw mobiles'. In the fourth version, each sequence is made from four rings and one bush. The bushes thread onto the vertical rod. To construct the piece, Martin laid the rings and bushes on a flat chequerboard five squares by five. Martin insisted, 'One is not working with a system towards inventing a finished work, one is inventing the process. Rhythm is a constructing force.' 'The kinetic artist is interested primarily in work whose realness is expressed as change through movement. So that realness becomes a matter of the indeterminate. However as soon as one is interested in the possibilities of change, one becomes interested in their limitation'. There are a limited number of ways of altering this mobile: the rows could be placed in a different order on the thread, either way up, close together or far apart, in any horizontal direction. The mobile can be turned by motor or by hand. The need for balance limits the scope for alteration, and the spectator is involved in this combination of freedom and restriction. Light plays a large part in the rhythms obtained.

MARY MARTIN
1907-1969

Mary Balmford studied at Goldsmiths' College and the R.C.A.. She married Kenneth Martin in 1939, but continued to exhibit under her maiden name as a still-life and landscape painter. She painted her first abstract painting in 1950 and made her first reliefs the next year. The Martins held their first 'one-man' exhibition in Cambridge in 1954. She pursued constructivism with a personal and limited vocabulary right up to her death. Her first relief was made of plaster; she later used plywood built-up into units, and from the 1950s, added vinyl, asbestos and stainless steel. After 1962 she restricted the unit to a standard half-cube, a triangular wedge faced with stainless steel. As each unit was identical, the interest lay rather in its distribution across the surface of the relief.

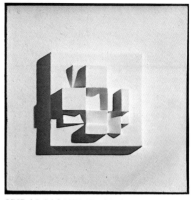

SPIRAL MOVEMENT 1951
Painted chipboard
457 x 457 x 95 T00586

Because the relief form falls into a no-man's land between painting and sculpture it has tended to be either neglected, or taken up with great interest as a solution to aesthetic problems. For the constructivists it was an art form which answered many of their needs: it used real space without the illusionism involved in both painting and sculpture. Reliefs hang at our eye-level, and, being flat, reveal everything at once, unlike three-dimensional sculpture which always has an unknown side. The constructivists liked this honesty. Reliefs echo the spectator's surroundings in the gallery; horizontals and verticals extend to floor and walls. About this work, Martin wrote, 'I took a simple element (a parallelpiped) and subjected it to a system of changes, not knowing what would happen to it, and without any knowledge of the final appearance of the work.' The constructivists' approach is not unlike that of a scientist conducting an experiment under strictly controlled conditions, in which he can only watch, not interfere. Martin found the carpentry difficult; it took a lot of work with the saw and sandpaper. She later acquired a file and electrical tools.

VICTOR PASMORE
b.1908

Pasmore never enjoyed a full-time artistic education. He exhibited with the London Group from 1930, and held his first one-man show in 1933 with the London Artists' Association. With Coldstream and Bell he formed the Euston Road school of naturalist painters 1937-9. It was through American interest in early European modern art that Pasmore came to abstraction. Reading Biederman introduced him to cubism, constructivism and neo-plasticism. Pasmore turned to abstraction in 1948, and this work was celebrated when Pasmore represented Britain at the 1960 Venice Biennale. From 1954 Pasmore taught painting at Durham University, and was architectural designer for Peterlee, County Durham. He returned to painting in the sixties, and though his work had become larger, and included more lyrical and painterly sections, he did not feel that this was because of new American painting, as he had in fact missed out on this stimulus while involved in pure constructivism. Pasmore stopped making constructed reliefs in 1965.

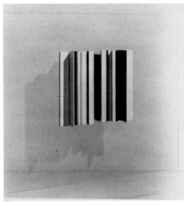

RELIEF CONSTRUCTION IN WHITE, BLACK AND MAROON
1962-3

Painted wood and perspex

686 x 737 x 133 T00609

Pasmore's first transparent reliefs date from the early 1950s.

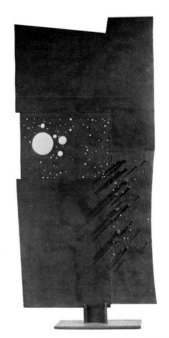

ROBERT ADAMS
b.1917
For biography see above

LARGE SCREEN FORM NO. 2 1962

Bronzed steel

1924 x 914 x 229 T00555

Adams must be linked to the constructivist group more through close affiliation than through style. He exhibited in all their exhibitions up to and including *This is Tomorrow*. Like theirs, his work lent itself well to architectural

collaboration. However, he, like Pasmore, already had a reputation when he joined the group in 1951. He had already had several solo exhibitions, and had received a commission for the Festival of Britain. Unlike the other constructivists, Adams used traditional materials, and did not use mathematical formulae. He did work from a vocabulary of basic forms – cylinders, cubes, rectangles – and his sculptures were generally in small scale. Their abstraction marked them out from the contemporary sculptural scene, and guaranteed their inclusion in the group's exhibitions. Adams began welding in 1955. The holes and the rods lend a three-dimensionality to the screen which was important for Adams, who stipulated that it should be well-lit from behind so as to highlight the perforations.

MALCOLM
HUGHES
b.1920

Hughes studied art in Manchester and at the Royal College. In 1959 he began to teach at Bath Academy. In 1964 he exhibited in Painting Towards Environment *in Oxford.*

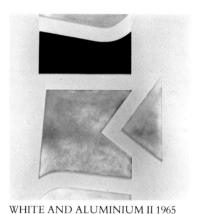

WHITE AND ALUMINIUM II 1965
Plywood, P.V.A. and aluminium on plywood panel
1829 x 1829 T00823

Hughes saw the use of the white gloss and the black paint in this relief as being pointers for his future work. The white gloss paint defines both the space and the light reflecting areas, and the black expands the negative tension of the relief into the 'advancing/receding idea of the painting'. Hughes added (in 1966), 'My work, at present anyhow, doesn't easily fall into "painting" or "construction". Because I tend to use aluminium and sometimes physical relief there is a tendency to place me with the Constructionists.' He added that using aluminium and relief grew out of his earlier paintings, and that he preferred to call his work 'Relief Painting' as he considered himself nearer to painting.

ANTHONY HILL
b.1930

Hill studied at St Martin's and Central 1948-51. He began painting with a dadaist-surrealist approach, and took up collage. In Paris in 1951-2 he met the great abstract artists Kupka, Delaunay, Seuphor and Vantongerloo, and helped to promote some of the first exhibitions of concrete art in London after the war. Seuphor and Vantongerloo had been involved in organizing the continental movements contemporaneous with the British equivalent: Circle. Hill then adopted a more disciplined way of painting, made his first relief in 1954 and abandoned painting altogether two years later. He first exhibited at Aspects of British Art in the I.C.A. in 1958. From 1957 he taught at Regent Street Polytechnic. His constructivist art has led him to exhibit all over Europe, and in America. In 1971 a Leverhulme Fellowship enabled him to work in the Mathematics Department of University College, London..

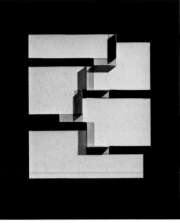

RELIEF CONSTRUCTION 1960-62
Rigid vinyl laminate and aluminium angle sections on a hardboard base
1105 x 914 x 48 T00567

Hill planned the elements of this construction by following a precise mathematical formula, and suggests that it can best be described in mathematical terms: 'the theme involves a module, partition and progression' accounting for 'the disposition of the five white areas and permuted positioning of the groups of angle sections.'

GILLIAN
WISE
b.1936

*Wise (Wise-Ciobotaru)
studied at Wimbledon
School of Art 1954-7.
She corresponded with
Charles Biederman,
who put her in touch
with Hill and the
English constructivists.
She first exhibited with
the Young
Contemporaries in
1957, and exhibited
with Anthony Hill in
1963 at the I.C.A..
Wise often worked with
prisms (sometimes
obtained from
submarines' periscopes),
aiming to achieve a
balance between the
composition and the
manipulation of mirror
elements. She felt
herself to belong to 'a
clearly defined tradition
of constructivism that
has developed in
England over the years
since the '30s'.*

RELIEF CONSTRUCTED FROM UNICURSAL CURVE NO 2 1967

Construction of aluminium and perspex on wood
813 x 813 x 40 T03776

Ostensibly so simple, this work illustrates the thin dividing line between balance and upset. This play on the tension among the 36 squares is increased by the use of different materials.

KIM LIM
b.1936

Lim studied at St Martin's, 1954-6, and at the Slade, 1956-60, and had her first one-woman exhibition in 1966. She worked in wood until 1979, but the adoption of stone, though sudden, produced images reminiscent of her earliest carvings in wood. In fact she began to work in stone after seeing a retrospective of her work, in which the juxtaposition of early and late pieces made her 'very aware of the pull within myself between the ordered, static experience and the dynamic rhythms of organic, structured forms. How to incorporate and synthesize these two seemingly opposed elements within one work became the starting point...'. In the seventies, Lim used light in terms of its regular intervals of shadow, but after 1979, harnessed it in terms of its movement and its reflection in water. She has always used light to counteract the weight of her materials. There is in her work a search for equilibrium, trying to balance out idiosyncracies in material often deliberately chosen for the challenge they thus offered. Kim Lim has also used printmaking as an alternative or preliminary process, using it to work out her ideas about 'space, rhythm and light'.

INTERVALS I 1973
Pine
1829 x 473 x 22 T02001

This work is from an edition of three, as is 'Intervals II'. She made no drawings for either work, and had the materials for them unused in her studio for about a year, and they stimulated her to make these sculptures. She did however make full-size models for the works. The artist has specified that 'Intervals I can be hung off the floor, or resting on it; either parallel with the wall, or leaning towards it.

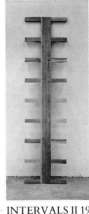 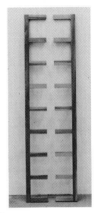

INTERVALS II 1973
Two pine units
v x 222 x v T02002

'Intervals II' cannot be displayed flat against the wall; for these two units the artist has specified three options: leaning against the wall, prongs outwards; leaning against the wall, prongs inwards (or flat on the floor); lying on the floor on their spines, with their prongs touching and thus stabilizing the work. Lim 'licensed' installation arrangements to owners and galleries; the Tate has one further installation option open to it, namely to integrate 'Intervals I' with 'Intervals II'. Then the three elements are leaned against the wall in alignment. 'Intervals I' becomes the central piece, and the prongs of 'Intervals II' point inwards to it. The space between the wall and the floor is important to Lim: the triangle of space between the vertical and the horizontal.

LILIANE LIJN
b.1939

Lijn was born in New York, and studied Archaeology and Art History in Paris. She returned to America in 1961 and began to work with plastics, fire, acids, light, reflection and motion. She took the name Lijn, and married the artist Takis. Back in Paris she exhibited her first 'Kinetic Poems', and, after two years in Athens, settled in London in 1966. She has exhibited very widely, and realised several commissions, including one for Bebington Civic Centre on the Wirral, and one for Birchwood Science Park in Warrington. Lijn has written, 'I work with light to dematerialize the solid volume and unify space and time. I make light traps, solid webs to receive and guide the beam, to make change manifest. I focus and choose the inevitable. I begin with the given and welcome the random'. Lijn looks at the way that different materials receive light and transform it. Although working with scientifically associated materials, her approach to science is intuitive and poetic. She is more than an optical-kinetic artist. She has worked with stones, prisms, wire coil, cones, perspex discs, neon light, letters and words, rotating cylinders and lenses. She uses specialist technicians to fabricate the works, while she 'works with her mind'. In the eighties Lijn has been making female figures with individual personalities, and mask-like heads.

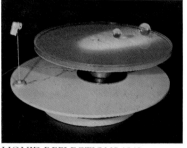

LIQUID REFLECTIONS 1968
Perspex disc and balls, mineral oil and water mix, electric light
838 x 1397 x 1143 T01828

When earlier pieces from the series 'Liquid Reflections' were exhibited in the Indica Gallery in London in 1967, Lijn asserted her presence as an artist working with light and movement who stood apart from Kinetic Art. The hollowed acrylic disks contained a mixture of water and oil which condensed into droplets creating natural lenses. The disc revolved slowly with two transparent plastic balls moving freely on top, lit by a shaft of white light. Lijn intended to create a 'multiple' art work, reproducible, freed from the touch of the artist. She aimed to harness elemental phenomena to 'discover energy thru (sic) the density of the materials used'.

103

The idea of sculpture being architecture and taking on architectural qualities for real, was, with the introduction of colour, one of the most important concerns for Anthony Caro and sculptors of the sixties. The confirmation of the priority of the sense of sight over the sense of touch is a result of this focus on architecture. Volume must be understood by looking at the handling of space, not by touching. Such concerns have a clear ancestry in the sculpture of Section Three. In the sixties the excitement of reconstructing our environment may relate to the optimism and prosperity of the period. Their reaction to the melodramatic sculpture of the fifties has already been mentioned; Annesley called it, 'some goddam, dark, murky underground field'. Before looking at who was at St Martin's School of Art, and who was taught by Caro, let us look at the meaning of their concerns.

Tucker wrote:

'In the past few years it has become general and natural to make sculpture which starts from the ground and is naturally part of the spectator's own "world".'

'The size-ratio of the new sculpture to the spectator invited him to identify its forms and spaces, its overall character and internal directions, with his own use of space, and in particular with the way in which space is modulated and directed inside buildings by their components, by walls, ceilings, floors, doors, windows, stairs, and so on. Thus a horizontal plane on its edge will read as "wall" or "fence", an open rectangle as "door" or "window", transition between levels as "stairs" or "ramp", each evoking the spectator's body experience of the

habitation of buildings, of passing through, around, across, along, up and down architectural spaces physically or visually.'

Although most of these sculptors intended their sculpture to go inside rather than outside (not least because its appearance depended on its being clean), there is a sense in which we can talk of their work as landscape sculpture. The experience of it is like the experience of urban landscape, and very different to the perceptions involved in confronting a figure. Tucker thought, in common with Tim Scott, that sculpture was now fulfilling the exciting aesthetic and physical potential of architecture, which had itself been taken up with more mundane questions. Scott felt that sculpture now performed the 'basic research' of contemporary visual art, and that architecture, being less concerned to make a 'statement', no longer fully satisfied deep plastic emotions.

'In a way I feel that sculpture is in a large part taking over the values that architecture historically reserved for itself.'

It is perhaps not surprising that Scott was influenced in his early work by Le Corbusier. David Hall echoes Tucker and Scott:

'My concern is to arouse an environmental change in the mind of the spectator through purely visual and mental participation with the object.' Confrontation between the sculpture and the spectator was a central concern to these sculptors; the mix of physical actuality, mental apprehension and personal experience was important. Tucker wrote: 'Sculpture also must have the generality of the world: the identity of the object: the character of a human individual.' Tucker was fascinated by the admix in the sculpture of being both of and not of the world; worldly because it is made of what the world is made of, other-worldly because its 'thingness' or 'objectness', sets it apart.

In thinking of sculpture as architecture, the floor was clearly a crucial factor. In a discussion about Caro's work by Annesley, Louw, Scott and Tucker, the four began by discussing Caro's use of the floor. The very idea of 'using' the floor was, of course, new:

'He started to use the ground not as a pedestal, but as an active element of the sculpture ... It didn't matter how far he got them off the ground. That first inch is as important as the next six feet. The difference between on and off the ground is what's important.'

'When Caro starts articulating the spaces on the ground as shape, then he begins to be able to control the directions in space ...'

'...it's like painting...Because it's activating both the spaces and the floor together. The whole environment of the sculpture has been activated in a very positive way.'

The point was to use the floor in terms of equality; neither to reject it nor to pay homage to it. Philip King wrote:

'It seemed to me that there was a danger in my earlier work that the ground was becoming too much of a fetish, and could take on the role of a new pedestal ... I have tried to expand my sculpture on the ground without using it as an area where sculpture can rest in order to move on, or as a thing to conquer.'

Caro's choice of pieces for what they represented materially was significant to his students. Tucker wrote,

'He was choosing shapes not for themselves as David Smith would – in other words for their internal image quality – but for their abstract qualities of lightness, strength and so on ... In other words, the sculpture would be about lightness, about strength, a certain kind of tension and balance, and materials were specific-ally selected for this reason ... we

thought he was a kind of found-object sculptor. I don't think he's anything like that'.

His followers admired Caro for concentrating on 'what is sculptural in sculpture' and leaving out all the other references; Tucker considered that 'Caro has opened up sculpture ... made it possible for us to make sculpture in a way that we couldn't have done had he not existed'. They admired his multi-directional sculpture (as opposed to his earlier unidirectional pieces); they admired a blending of the physicality of elements (their rust, rivets, and industrial connotations) with Caro's declared purpose, so that the visual balances the physical; they admired his emphasis on process, whereby it (and its mastery) itself becomes the goal – thus allowing the sculpture to evolve out of it; they admired his sheer panache in dealing with material.

It became common to use the old terms carving and modelling to describe new sculptural processes that were very far from these age-old techniques. In America the term 'assemblage' or 'putting-together' was used in contrast to carving, but the British stuck to the old term. Trying to explain Caro's procedure, they called him a modeller, referring to the fact that his process was additive. It was also light-handed; Caro never seems constrained or hampered by the weight of his material – iron looks like paper – and Tucker described him as 'using metal like a really high-class, refined sort of clay'.

One of the most obvious characteristics of this period's sculpture is its colour. Although, on the surface, colour serves to group these artists' works, they used and explained it in different ways. In 1968 Philip King wrote,

'Colour sometimes can even stand for shape. Sometimes it may only emphasize or reduce it. It can give a volume greater or lesser mass, it clarifies shapes or confuses them.

Colour comes in towards the end of making a work, but I feel it is subconsciously carried in one's mind throughout the working process, as stored up experience, and is a definite affecting force.

In its final role colour seems to become the escape-window through which matter or rather stuff is energized and seemingly reborn with light.' Contrary to what was often written about these sculptures, colour was very much used as an emotive force. King used colour for its fragility, as 'the life-line into this invisible world where feeling takes over from thinking', and Scott, while admitting that colour served a structural purpose in uniting different materials, added that it was important in giving 'emotional qualities'. Scott implicity refutes Ian Dunlop's introduction to the *New Generation* exhibition, in which Dunlop declared that the coloured skin rids sculpture of tactile associations. Scott wrote,

'The use of colour surfaces in sculpture is an expression of the continuing awareness of surface as texture …'.

Anthony Caro taught at St Martin's School of Art from 1953; his pupil-associates (Scott, King, Annesley, Tucker, Witkin, Bolus), all born in the thirties, studied with him at St Martin's in the late fifties, and all went on to teach there. St Martin's advanced sculpture course, run by Frank Martin, had not received official validation, and so remained 'vocational'. The department largely produced enough teachers to supply its own demand, and the concentrated nature of this cycle has meant that it is more than usually just to speak of one art school in terms of an artistic movement.

When they were students at the School, Caro had not made the break into the style for which he became famous. He was still working in plaster, and King remembers that 'an endless source of talk was the new American painting – Pollock, de

Kooning, Still, Rothko – and the realisation that sculpture had some catching up to do'.

These six sculptors became known as the 'New Generation' sculptors when they exhibited together at the Whitechapel in 1965. They were not alone, for Roland Piché, Christopher Sanderson and Derrick Woodham were also included. This exhibition received a great deal of attention and coverage, bringing with it a new note of glamour. It sought new patrons, and in Alistair McAlpine, found its collector.

In the same year the Tate Gallery consolidated this sculptural showing with an exhibition entitled *British Sculpture in the Sixties*. Although self-consciously setting the exhibition in contradistinction to that at the Whitechapel, juxtaposing the older with the younger generation, it is nevertheless surprising to see how radically different is its list of contributors: Adams, Armitage, Ayrton, Brown, Butler, Caro, Chadwick, Clarke, Clatworthy, Dalwood, Ernest, Frink, Fullard, Hepworth, Hill, Hoskin, Kneale, Martin, McWilliam, Moore, Paolozzi, Richmond, Rugg, Startup, Turnbull, Wall, Wise and Wright. That the New Generation sculptors were receiving an unprecedented amount of attention is indicated by the Tate catalogue's introduction:

'The public impact that the Tate sculptors should have made had they been shown together in London ten years ago (as they should have been) has been irretrievably lost, by familiarity and by maturity; and we now find ourselves in the position of risking undervaluing them simply because they are not the latest thing.' The selectors recognized the 'real challenge' that the New Generation group posed, and they were right.

Nevertheless, only four years later, another St Martin's sculptor – Roland Brener – could take a cool look back:

'Caro infused dynamic potential into British sculpture and this was exploited by the New Generation to a limited degree. The initial excite-

ment felt at the first New Generation sculpture exhibition has faded, despite continuing efforts of the Whitechapel Gallery to contrive annual experiences of a similar nature.'

Brener was among the next batch of St Martin's students, there in the early 60s, who worked at the Stockwell Depot and looked for a very different way in which to present their work. They considered that the New Generation had suffered from their sudden rise to fame, and had 'lapsed into a form of sculptural rhetoric'. Other contemporaneous sculptors – Long, Flanagan and Mc-Lean – also at St Martin's, were soon to present further challenges to the New Generation orthodoxy.

ANTHONY CARO
b.1924
Caro studied engineering, served in the Navy and then studied sculpture at the Regent Street Polytechnic and the R.A. schools. He was assistant to Moore 1951-3 and then began teaching at St Martin's under Frank Martin. In 1959 he spent two months in America and was impressed by colour-field painting, Morris Louis, Kenneth Noland, Jules Olitski, and by the sculptor David Smith. He changed from plaster to welding, unable to make the change to non-figurative sculpture without getting away from clay and plaster. His first exhibition of his post-America sculpture was in 1961, and in 1963, his one-man show at the Whitechapel Art

TWENTY-FOUR HOURS 1960
Painted steel
1384 x 2235 x 838 T01987
'I started working in steel in around 1 January 1960', wrote Caro, 'and made two or three steel pieces which I destroyed before making 'Twenty-Four Hours'', which he finished in March. It was made in Caro's garage, using a gas cutter and gas welder (he had no electric arc welder at the time) and the raw material came from the scrap yards at Canning Town. He painted it with dark Valspar paint to make it 'look straight forward: no art props, no nostalgia no feelings of preciousness associated with something because it's old bronze, or it's rusty encrusted or patinated. So I just covered it with a coat of paint.' Working in a confined space meant that Caro was very intimate with his sculpture, and, unable to step back to look at it, he could not use

Gallery of fifteen large pieces was public confirmation of an importance already recognized in art circles. In 1963-4 and in 1965 he taught at Bennington College, Vermont, and in 1968 resumed teaching one day a week at St Martin's. Greenberg considered him to be the only sculptor who bore comparison to Smith. America was very important for him in shedding 'History' and fine art qualities. He discovered there a 'tremendous freedom in knowing that your only limitations in a sculpture or painting are whether it carries its intention or not, not whether its Art', but always attributed the proper use of space in sculpture to Picasso's and Braque's cubist painting.

his traditional knowledge of balance and composition. Similarly, he believed that his sculpture should continue to be viewed indoors, so that it relates to the human scale, and that neither it nor the spectator are 'out-scaled' by the enormity of nature. 'Twenty Four Hours' was bought by Clement Greenberg, from whom it was bought for the Tate.

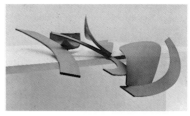

PIECE LXXXII 1969
Forged steel with found steel elements, painted
445 x 1206 x 1460 T01151
This is one of a series of table sculptures that the artist made from 1968, which surprised people by then used to the convention of basing the sculpture on the floor. The aim was the same however: to activate the space under and around the sculpture and to bring it into the everyday world. The table relates to a spectator's scale just as does the floor. The artist wrote, 'My Table Pieces are not models inhabiting a pretence world, but relate to a person like a cup or a jug. Since the edge is basic to the table all the Table Pieces make use of this edge which itself becomes an integral element of the Piece.'

MICHAEL BOLUS
b.1934
Bolus was born in South Africa and came to England in 1957, where he studied at St Martin's, where he later taught. Bolus began modelling, then moved on to carving, in a manner often reminiscent of Brancusi. He found that he was in fact constructing in stone. His interests in balance and extension of form were much better met by metal. He worked around modules, arranging his installations low on the floor from a few basic repeatable units. His

111

work, like Caro's and Scott's (but unlike that of Tucker and Turnbull) can look very different from different angles. He used colour almost as a separate element, with the quality of being either attachable or detachable. After 1963 Bolus welded less frequently, and his subsequent work was simply self-supporting. He later turned to painted steel grid- or lattice-like structures, which he exhibited at The Condition of Sculpture show of 1975, which was selected by Tucker.

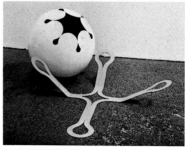

7TH SCULPTURE 1965
Painted chromium
768 x 1835 x 1206 T01353

Bolus is very interested in surface, and in '7th Sculpture' he is playing on the relationship between the essential flatness of the surface skin, despite the fact that it wraps into a three dimensional form. The cross shape and the void in the sphere can be seen as splashes of paint on the surface. Neither line nor plane need have any cut-off point, they can be continuous; plane can make volume and line can be three-dimensional.

TIM SCOTT
b.1937

Scott studied architecture 1954, and then sculpture from 1955. From 1959-61 he was in Paris, where he worked in the Le Corbusier-Wogenscky atelier, and wrote a thesis on Corbusier's Villa Savoye. He greatly admired Corbusier's Ronchamp chapel as sculpture. Brancusi was another important interest. He began by working in plaster, and when he returned from Paris to see Caro's latest work (eg 'Twenty-Four Hours'), he found it 'too much like the junk art of the fifties'. In fact the first things to appeal to him at St Martin's were a piece by Annesley and another by Tucker. Scott wrote (in his Whitechapel exhibition catalogue), 'I use

PEACH WHEELS 1961-62
Painted wood and glass
1219 x 1372 x 914 T01215

The pairs of wheels are wooden, and are separated from each other by a vertical glass sheet. The change in scale on either side of the glass is both unexpected and thought-provoking. The entire sculpture depends simply on repetition and proportion. There is a certain surreal quality in Peach Wheels, in which very un-arty objects, which suggest an everyday utilitation function, are painted in a soft, 'inappropriate' colour. This sense of invention, characteristic of cubist-surrealist thinking, was understood by Scott, who, excited by sculpture's new freedom, declared that 'it can achieve poetry in which the language itself is invented'. At this stage Scott was using colour simply to characterize the mass of the object.

semi-'geometric' forms that are known beforehand. I do not use them because I am interested in some Platonic ideal, but because I want them to be recognised and then forgotten'. He was concerned to challenge the convention of one piece closed volume sculpture, and added, 'It is not enough to produce work which in size will compete with the spectator and consequently enclose him: the problem of sculpture is the problem of SHAPE and it is through shape that impact must result.' By using glass and perspex Scott was able to counter visual weight while retaining the idea of a kernel, and its support of solid mass. In 1965 he discovered the adaptability of acrylic sheet, and began to use steel tubing. At the end of the decade Scott turned to working with real mass and real weight – making density actual – by using forged steel.

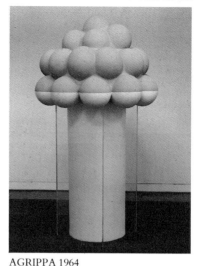

AGRIPPA 1964

Painted fibreglass and perspex
1886 x 1130 x 1130 T01363

This sculpture, like 'Peach Wheels', is one of an edition of three. It was produced after a depressed period, in which Scott was thinking of leaving England. Until 1962 he was also obliged to work full-time as an architect. 'Agrippa''s exuberance could be understood in terms of this background (Agrippa being a victorious Roman general), and as a reaction to the austerity of the work of this period, but more importantly it shows us Scott using colour as a constructive element for the first time. In 1972, Scott wrote, 'Colour became, for me, a crucial issue in sculpture from about 1964-5 on until recently … I felt that it was one aspect of colour that was paramount to its development'. In 'Agrippa' however, colour is being used as a separate element, and it was not until the following year that Scott fused colour and form to become a unified constructive force. Scott saw 'Agrippa' as a flower, and although its exuberance was perhaps a necessary reaction to what had gone before, he considered that it had failed as a sculpture.

DAVID ANNESLEY
b.1937

Annesley is both a painter and sculptor. He went to St Martin's intending to study painting, and reverted to it at the end of the sixties. At St Martin's he was part of the particularly close group around Caro comprising Tucker, King and

Bolus. He shared a distaste for the sculpture of the fifties, but in fact began by thinking of his sculpture in a way associated with the fifties: as urban art, suggestive of Paolozzi, the pop artist Richard Hamilton and art brut.

Annesley used both found and freshly cut elements, giving neither chance nor choice priority. He began constructing in metal almost immediately, which he appreciated for its combination of rigidity and fluidity. Up to 1963 Annesley used colour because of its everyday normalcy, but when he started to use several colours its use became more complex. To use more than one colour was seen as a tremendous breakthrough, and seemed especially liberating because it felt like 'breaking all the rules'. Annesley said that Bolus made the first multi-coloured piece, and he the second. Annesley admired the painter Kenneth Noland (with whom he spent some time), for taking a structure and then working with colour inside it, 'in a very non-compositional way'. Annesley began to use a grid system for his sculpture in later years. By the end of the decade Annesley had become tired of the intellectually rigorous and restrictive nature of sixties sculpture, whose process he described as 'intensifying and refining, crystallizing and clarifying'.

SWING LOW 1964

Painted steel

1283 x 1759 x 368 T01340

'Swing Low' is notable for its domestic scale, a trait common to all Annesley's work. This scale should not only be attributed to restrictive studio space: the scale was part of the programme of putting sculpture into the everyday inhabited world, and Annesley not only saw his work as 'interior sculpture', but also based it on a human scale of span and measurement. Steel was the ideal material in both meeting the requirement that the material be ordinary or 'neutral', while also ideally performing the functional needs of the sculpture. 'Swing Low' is from an edition of three.

PHILIP KING
b.1934

King studied languages at university, studied at St Martin's for a year 1957-58, and was an assistant to Moore 1958-60, and also, briefly, to Paolozzi. The experience of Greek art and architecture, and its symbiotic relationship with its environment, enthused him about the potential in abstract art. He taught at Bennington College, Vermont for a term, and in 1967 began to teach at St Martin's.

King was very influenced by a 1959 exhibition of New American painting. He has a modeller's approach to material, 'I like to shove, push, squeeze things together. I want to feel it more like a growing thing to do with space and light'.

He first used the cone shape in 1962, looking for something to generate its own support. Brancusi had given him a lead: 'much of the power of Brancusi comes from the simple constructional principles he uses, objects lying on top of each other in a believable balance.' In 1960 he had decided against using steel, because it involved a collage technique. Although by the end of the decade King was using steel, his relative affluence now enabled him to avoid bric-à-brac (found steel almost inevitably results in a collage, or sticking together, effect) and to avoid pretending steel was something other than it was. He used it in an open way, without trying to weld concealed or unnaturally difficult joints. Despite different materials (clay, plaster, cement, wood, fibreglass, plastic, steel)

AND THE BIRDS BEGAN TO SING 1964
Sheet metal
1803 x 1803 x 1803 T00737

King first made this sculpture in fibreglass in America, and had it remade in steel by Feromet Ltd, being present at every stage during its making. King wrote, 'the static quality of the outer cone is merging into the dynamic inside activity.' King liked the cone as a 'very large, very much earth-bound shape that will provide the maximum challenge in an effort towards expansion'. The cone is a simple way of achieving a 'standing, piling-up idea', and to minimize mass, King began to use a split cone. It is a simple and stable base on which to try out experiments with shape, contour, volume, surface, colour and space.

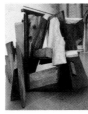

WITHIN 1978-9
Elm wood, slate, oil paint
2210 x 3200 x 2590 T02345

With the works leading up to 'Within' King is no longer interested in the difference between inside and outside; in the exterior elucidating the internal structure. He now displays the spaces which objects inhabit both on their inside and out. He identifies a new feeling of 'push-and-pull' in these works, with their more 'all-over disposition' of interest. The composition is more dispersed, no one element or theme is dominant. His approach in making 'Within' and other such pieces was improvisatory; setting off without pre-conceived ideas, and letting materials suggest shape. It is made from thirty-two pieces either welded, glued or bolted. Although it might appear random, his working process in fact ensured that pieces had a reason and purpose for being there in structural terms, and his instructions for erecting the work affirm this cumulative logic.

115

King's work has always been about honesty in construction. Credibility without artifice can be a powerful constructive principle. Openness of form involves associations very much part of our everyday physical experience of the world; we can see the processes of furling, unfurling, peeling open, wrapping. King has moved towards outdoor work, or at least towards a sense of how landscape and natural light affect the perception of the work and its colour. At the same time his sculpture has increased in its size range; becoming both larger and smaller.

WILLIAM TUCKER
b.1935

The knowledge that Tucker considers details other than the artist's birth date and the sculpture's materials to be obfuscatory diversions from the sculpture itself, which, if it is successful, will be self-explanatory, makes it especially difficult to write about him. Tucker studied sculpture at Central and St Martin's 1959-62, taught at the latter from 1962, and was a Leeds Gregory Fellow from 1968 to 70. He is an unusually articulate and diligent sculptor, whose systematic enquiry into the nature of sculpture has led to a series of frankly didactic sculpture, alongside an impressive body of writing. His own research into what this century's modern sculpture has involved in terms of its formal questions and answers have resulted in a book, and in an awareness of what he, as a sculptor, stands heir to. He has perhaps been more

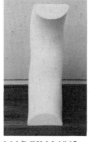

MARGIN I 1962
Painted fibreglass and steel
1124 x 781 x 413 T01372

'Margin I' was conceived on a flat surface, and the action on the flat – drawing or cutting – determined its three-dimensional qualities. In 'Margin I' an outline was drawn on a blackboard, transposed onto flat steel, and then into a three-dimensional projection which the outline had suggested. Different angles give very different views, and suggest different origins for the sculpture. Tucker is modelling with contour rather than mass; but the whole work is an exploration of volume. Tucker felt that Caro was insufficiently concerned by volume, and Tucker sets out to analyze its most basic principles in this, and other, works.

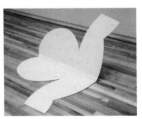

UNFOLD 1963
Painted aluminium
711 x 1172 x 1340 T01374

'Unfold' is another example of a work dealing with construction, and how we perceive it. The simple act of folding and painting in two different colours makes the sculpture unusually illusionistic. The threshold between flatness and volume is easily perceptible and yet the more compelling. 'Unfold' appears to be, but is not, symmetrical. The lighter pink paint on the larger half conceals this from us. Underneath these constructive concerns, which remain paramount, there is another level in 'Unfold' (and 'Margin I'), which suggests the human form and even conveys an erotic quality. Such associations are very rare in Tucker's work.

single-minded than other sculptors of his generation, refusing to relinquish these formal concerns even when they were no longer fashionable. The exhibition he selected in 1975 for the Hayward Gallery, The Condition of Sculpture, *is in many ways a manifesto for all that he has defined for himself as being involved in sculpture. His choice of sculptors who 'accepted the condition of sculpture as I understand it' included many 'sixties' figures among whom were some who are represented here: Scott, Witkin, Bolus and King. His condition? – 'sculpture is subject to gravity and revealed by light. Here is the primary condition. Gravity governs sculpture's existence in itself, light discloses sculpture to us'. The sculpture is passive. The world gives light, the sculpture receives it; the spectator moves, the sculpture is still. At most a sculpture 'resists our gaze, receives light, withstands gravity'.*

Tucker identified a threat to the acceptance of these fundamentals by the relief form, 'whether the ground of relief has been the wall or the floor, or recently the surface of landscape itself' (cf Richard Long). 'Sculpture's "free-standing" is thus more than a neutral description: it is an aspiration. To stand free, for sculpture, demands a positive acceptance and understanding of its condition; and it follows that a free sculpture will remain inconvenient, obtrusive – a challenge to facile and conventional views.'

KARNAK 1965
Painted fibreglass
548 x 1368 x 1321 T01378
Works such as this mark the culmination of several years' use of strong colour by Tucker, using it as a fully constructive element in its own right, without denying its interaction with the sculpture's other properties. The bent-up plane harks back to 'Unfold', and Tucker is of course again playing with plane and volume. The simplicity with which the sculpture meets and is then raised off the ground (ie by a simple bending) is striking.

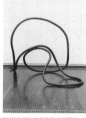

BEULAH I 1971
Painted iron
1511 x 2661 x 1499 T01818
In 1972, Tucker wrote, 'In my own sculpture from 1960 until about three years ago, I now feel I was still largely conditioned by the enclosed object aesthetic ... the work I am now doing (is) clearly distinctive from the earlier work: in fact the size and the fact that they start on the floor are the only common factors. The crucial difference seems to me to lie in the material. The earlier sculptures were made of 'no-material', ... a possibly over-emphatic rejection of the association of particular forms with particular materials in previous sculpture. It was, in effect, a kind of purging, after which I felt I could look at materials quite freshly again ... Any material now seems possible; the tool or technique is the main determinant of the structure (rather than a pre-figured plan or image) ... I feel the sculpture is a good deal more abstract – having 'come through' the world as it were ...'

As we have already seen, New Generation sculpture provoked reactions, (and it was freqently Caro who took the 'blame') and one important new approach came from the next generation of students in St Martin's itself. The Stockwell Depot sculptors have already been mentioned for the emphasis they put on the environment of the exhibition, and this was a feeling that they had in common with this other St Martin's sculptors such as Flanagan, Long and McLean. They were critical of the way in which New Generation works were presented by their makers, who appeared ignorant or negligent of the gallery context. The gallery situation could be used as a creative stimulus, and it inspired pieces that were not exactly installations but which certainly took account of their physical surroundings. Bringing sculpture 'out of itself' was partly made possible by the very success of the enquiry into the nature of sculpture that had been carried out by the first generation of St Martin's sculptors. The second wave of St Martin's were able to work from the basis of this new confidence and start to engage with the world again.

The rigour of Caro's enquiry into the nature of sculpture left little for the sculptor to analyze, and the most significant factor remaining to him was that, he was, after all, a sculptor. Once the artist has identified himself as a sculptor, everything with which he engages seriously becomes sculptural. In 1963 Barry Flanagan asked Caro, 'Is it that the only thing a sculptor can do, being a three-dimensional thinker, and therefore one hopes a responsible thinker, is to assert himself twice as hard in a negative way. I might claim to be a sculptor and do everything else but sculpture. This is my dilemma.'

However, the sculpture of this

period was not exclusively egoistic, and was in fact especially sensitive to the qualities of material. The stress on states and processes meant that the artist did not impose his ideas on the material, but let the fundamental nature of the material speak for itself. The artist tested his own involvement with the material, and looked for his material in a much wider world than previously used. This is a reprise of the earlier twentieth century interest in truth to material, and indeed much of the sculpture of this century is a variation on this theme. Perhaps most notably, some sculptors began to return to the natural world. Material was allowed to change, or could be dispensed with altogether. At this point the sculptor's gesture came to the fore. An alternative was to choose the material and do nothing at all to it, other than providing it with a new context. A new interest in Duchamp's ready-mades was significant in this period.

The nature of the sculptor's interaction with the wider world necessarily involved factors of impermanency and changeability. Human activity is moving and changing. A 'moratorium on objects' put a premium on the artist as art object, and behavioural and theatrical modes were widely used. Stuart Brisley's installation pieces – in which he himself is installed in some physically developing (and usually unpleasant) situation – also stimulated thinking about the sculptor's relationship with his material/environment, the sculptor as sculpture, and his autonomy. These sculptors played upon the threshold between concept and object, and opened it up for discussion. Inevitably, situations and interventions were often best recorded in photography, and this became an important new vehicle for the sculptor in this period.

While some of the sculptors from St Martin's were involved in theatrical events (notably Gilbert and George and McLean), there was nevertheless still a strong note of

intellectual analysis in their 'sculpture', even if it was no longer solidly three-dimensional.

Another group of sculptors reacting against New Generation was in the Royal College of Art. Again the theatrical is a significant mode in their work, and it frequently approached the vicious and sadistic. Set-piece works evoke emotion in a pre-determined way, and frequently suggest frustration. Michael Sandle is a notable precursor in these theatrical arrangements, and might be associated with Graham Ashton, John Cobb, Kenneth Draper, Lloyd Gibson, Martin Naylor, and Carl Plackman. Their work was presented as meaning-full, gathering meaning through atmosphere and associations which sometimes hark back to Surrealist or Duchampian art, and are sometimes more directly symbolic. The most direct influence on them may have been the constructed work of Robert Rauschenberg, who stated his desire to work in 'the gap between art and life'.

Various sculptors produced a kind of sculpture which was more straightforwardly and simple-mindedly of the everyday world, in reaction to Caro's laboratory or greenhouse atmosphere. They returned to the figure, to the street, to assemblages of popular material, and in this sense form a strong link with fifties and Pop Art. Paolozzi was in fact consolidating his reputation in the sixties, and forms an important one-man bridge with fifties' interests. A large Schwitters exhibition in London in 1958 had been an important stimulus to sculptors interested in relief work, with Schwitters' concentration and distillation of urban life. Mark Boyle exhibited his reliefs of London streets in 1963, and Joe Tilson, who had begun making wooden structures in 1960, had adopted a much more urban iconography by 1962.

Iconography in any form was in strong contrast to the abstract sculptures of the New Generation,

and much of it was deliberately evocative of the throw-away society (eg Lacey), or satirically nostalgic for 'The Good Old Days' (eg Fullard). Lacey began to make sculpture in the mid-sixties. He left the Royal College in 1954, and found that his fine-art education faded away very quickly. He involved himself instead in various theatrical jobs, and then began to produce robots. However he soon went back to performance, this time of a more mythical nature.

The theatrical was also important for Nicholas Monro and John Davies, but, more importantly, they adopted the figurative idiom as the way to restore substance to sculpture. Like Leonard McComb, Monro and Davies sought to reproduce the human species very exactly. Davies cast face and heads from life, the clothes and shoes are everyday, the hair is real, and even the glass eyes conceal their artificiality.

The surface of Davies' young men is akin to that of Boyle's road or earth surfaces in its disconcerting reality. Clive Barker's 'Splash' is also very close to and yet very far from reality. Davies, Boyle, Barker and Lacey share a textural richness which is culled from everyday life. Their work seems unusually dense, and this density links it to fifties' collage and sculpture, as do its archaeological overtones. Its solidity is in contrast to the light-handed conceptual elegance ('now you see it, now you don't') of the sixties' photoworks, performances and propositions of the St Martin's school and others.

Sculptors of the seventies were part of an emerging internationalism. Between 1968 and 1972 there was a remarkable number of international exhibitions which included British sculptors. Exhibitions increasingly involved artists installing their own works. Inevitably what is left for us to show has to be that which was more or less fixed; performance art cannot be preserved, and Brisley's is the only installation in this display. Our exhibition tends towards objects

rather than theories, and the contemporary use of photography is poorly represented. The generation that succeeded the New Generation wrested 'Modernism' away from the abstract. Abstract painting and sculpture could no longer lay exclusive claim to modernism.

JOE TILSON
b.1928

Tilson studied under Auerbach and Kossoff at St Martin's 1949-52, and then at the Royal College, 1952-55. He taught at St Martin's 1958-63, and then at various colleges abroad. Tilson is a multi-media creator, using wood, plastics, painted surfaces, photos, screenprinted images and collage. He quotes from the everyday world and topical events, and he best exploited his gift in communication in his large-scale art and murals. It is easiest to label him a Pop Artist, and he was among the first generation of English Pop Artists, associated with the Institute of Contemporary Arts and Lawrence Alloway, Paolozzi and Hamilton, and which included Peter Blake, David Hockney and Ron Kitaj.

WOOD RELIEF NO.17 1961
Wood relief construction
914 x 1219 x 51 T00480

STUART BRISLEY
1933

Born and educated in Surrey, Brisley attended Guildford School of Art (1949-54) and the Royal College of Art (1956-9); thereafter, he chose to develop his ideas abroad at the Akademie der Bildenden Kunste, Munich (1959-60) and Florida State University, USA (1960-62).
On his return to London, Brisley's sculptural work (using perspex and kinetic structures) was overshadowed by his desire to participate in Performance situations as a stance against consumerism and authoritarian methods of social control. In countless ad hoc venues, Brisley subjected himself to sensory deprivation ('And for Today... nothing', London 1968) or hunger ('Ten Days', Berlin 1973, whilst on a DAAD fellowship) enduring each ritual as a form of purification for both artist and viewer. In 1976, he took up an artist's residency at Peterlee New Town and from 1980 onwards began work on 'The Georgiana Collection', a series of site-specific installations which explored Georgiana Street where he lived in North-West London; Brisley now teaches at the Slade School of Art, London.

NUL COMMA NUL 1984/86

Painted plywood, steel mesh, clothing, electric light
2440 x 1830 x 6250 T05002

'Nul Comma Nul' was made in response to a commission from the Arkwright Arts Trust, based at the Camden Arts Centre, for a work relating in some way to Orwell's *Nineteen Eighty-Four*. Brisley took the aspect of the book which 'satirises the period of Stalin's power but I have not made a work about the period ... the goal of Stalinist socialism seemed to be a condition in which everyone (except Stalin himself) was the inmate of a concentration camp and simultaneously an agent of the Secret Police'. 'Nul Comma Nul' evokes this double sense of being both prisoner and warder. 'Nul' means 'nothing'. The installation surprises the viewer, who, once confronted by its interior, is blinded by a bright light from within. When the eyes have become accustomed to the light, they make out a heap of old clothes on the floor. On leaving, the viewer is likely to see his own shadow against that of the wire mesh at the front of the installation. The structure had to be re-made when it was exhibited again in 1986, and this accounts for the two dates of fabrication.

MARK BOYLE
b.1934

It is incorrect to speak of Mark Boyle as an individual artist, for since the mid fifties he has worked with Joan Hills, and, more recently, with their children. They can be called the Boyle Family, although they have taken other names such as 'The Sense Laboratory'. They have always been involved in making precise reconstructions of the earth's surface. In 1965, Boyle wrote, 'My ultimate object is to include everything. In the end the only medium in which it will be possible to say everything will be reality. I mean that each thing, each view, each smell, each experience is material I want to work with ... it is necessary to 'dig' reality, to uncover its infinite layers and variations ...'.

'The most complete change an individual can affect in his environment, short of destroying it, is to change his attitude to it ... To study everything we may isolate anything. Perhaps we may one day isolate everything as an object/experience/drama from which, as participants, we can extract an impulse so brilliant and strong that the environment, as it is, is transformed.'

In 1964 they started randomly selecting sites, and in 1968 announced the beginning of their 'Journey to the Centre of the Earth', involving 1000 sites all over the world, which were randomly selected, but then rigorously adhered to. The challenge of recreating different kinds of surface is the stimulus behind the work. 'Everyone in our

HOLLAND PARK AVENUE STUDY
1967

Epikote (epoxy resin) and fibreglass with found materials

2388 x 2388 x114 T01145

The study is one of a series of 100 London sites selected at random from an area of West London, of which twelve had at this point been done. Boyle wrote, 'The technique involves lifting the moveable material on each site and holding it in the same shape that the film was in on the site until we can back it with a reasonably precise presentation of what lay underneath the film on the site (ie the immovable material). In some cases, the presentation is microscopically accurate. In others it is merley satisfactory to the naked eye ...'

family knows their way around the resins, can break down, crush and prepare the colours, can lay a pretty good polyester and fibreglass lamination over quite a large area and so on. It's when we don't know what to do that people really have to prove themselves.' This journey has gone on over the last twenty years.

CLIVE BARKER
b.1940

Barker studied at the Luton College of Technology and Art. He began creating art objects in 1962. He lectured at Maidstone College of Art, 1965, and at Croydon 1971. In 1978 he worked on a series of twelve bronze heads of Francis Bacon, grotesque and deathly objects. Barker plays with the head, and with the gas-mask, stubbornly presenting this horrific object, which, ironically, was designed to shield us. Casting them in metal means we cannot escape or discard them. Barker's other pieces are also connected with war, and the consummate skill with which they are presented makes them the more chilling. Like Davies, Barker uses the figurative mode as the most potent bearer of subject matter.

KEITH MILOW
1945

Milow studied at Camberwell and the Royal College 1962-68. He lectured in printmaking at Ealing College 1968-70, and held the Leeds Gregory

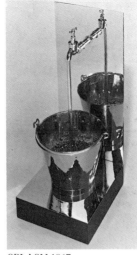

SPLASH 1967
Chrome and nickel-plated metal, wooden base and ballbearings
864 x 356 x 356 T01211

The artist wrote, 'I am concerned in my work to disguise familiarity. I see the buckets as the logical extension of the Van Gogh chair series. On that occasion I took a well-known pictorial image, and transformed it by making a chrome model of it. But I do not always acquire my objects from art. I am equally inspired by just driving along a street, going into a sweetshop, seeing a waitress carrying a tray with knives and forks on it'. 'I started making objects in 1962. The early works were of leather: after incorporating chrome in "Tribute to Jim Dine" in 1964 I have worked generally in chrome... The interest was partly stimulated by what I saw at the Vauxhall Car Factory (where he worked as a leather fitter 1960-61). Badly galvanised metal is altered into beautifully produced sleek bonnets'. This interest in transformation is akin to his interest in deceptive presentation or gift-wrapping. It took a series of nine to twelve processes to dip the bucket in chrome, and the usual size of the chrome baths restricted the size of his works. The buckets were unusual for him in being ready-made objects, rather than originally made by Barker in metal.

125

Fellowship 1970-72. From 1972 to 1974 he worked in New York on a Harkness Fellowship. He began teaching at Chelsea in 1975; more recently he has settled in New York. Milow's work is akin to that of the 'Fundamental Painting' movement, and to that of the French artists of 'Support-Surface', and like them he works around the relationship between the art-work's support (eg in conventional terms, its canvas) and its surface. It is also possible to place him within a context of constructivism (see Section Six). He may be seen as taking painting apart and reconstructing it as sculpture – deconstructing and reconstructing – using sections and projections. He began by making prints, but his breakdown of form soon led him into the third dimension. He reconstructed prints of architecture or of famous works of art. After extensive use of the cross image, he has moved into other forms (the cenotaph, the ship), but his work still projects from the wall. His 'Split/Definitive' series used plywood hung at right angles out from the wall; the paint on the plywood played with shadows and expectation; mixing reality with unreality. Milow uses mirror images, inversion, displacement and superimposition to heighten the conflict between object and illusion. He is presently working in lead, and in cement with copper oxide coloration.

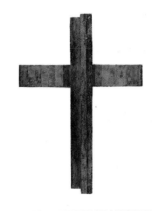

A CROSS BETWEEN PAINTING & SCULPTURE
Relief: glass fibre, polyester resin and wood
1155 x 870 x 210 T04159

In the seventies Milow took the cross shape as his starting point; it is both an extremely simple shape, yet one full of potential for subtle change, and laden with meaning for our culture. 'Cross' also works as a pun, as is obvious from the title. Milow has built up the pieces in varying layers, staggered them, altered the lengths of the arms. The full effect of his enquiry is best seen when a number of crosses are displayed. He has also varied surface texture, working with wood, resin, paint, metal powders, plaster and cement, and scale. Impressions of weight are offset by impressions of lightness, and shadows add to the effect. Although the cross theme began as a formal concern it has, almost inevitably, taken Milow into the realm of the monument and of architecture. The cross pieces resemble sections from architectural mouldings.

126

BRUCE LACEY
b.1946

Lacey was an art student for six years, and left the Royal College in 1954. He took jobs working as a tap-dancer, knife-thrower, musician, and making props for the Goons. In 1962 he made his first assemblage sculpture for a gallery window, and between 1962 and 63, made two robots which appeared with him in his act entitled, 'An evening of British Rubbish'. In 1963 he exhibited 16 'automata and humanoids' at Gallery One. 'The Objects I make are hate-objects, fear-objects, and love-objects. They are my totems and fetishes … They may be what we know as art, they may not be, but if they are not, they are what art should be'. They were also intended to be object lessons, or warnings: 'Art… should be awakening (man's) conscience and his awareness of life as it is and what it is going to be, as we move forward to a frightening future, where man's very individuality and personality may be lost'. A Schwitters exhibition at the Marlborough Gallery in 1963 encouraged him to exhibit his own constructions. He moved from making humanoids, to setting them into interior installations, and, ultimately, to working with interiors entirely. Robots became more important as part of his performance than as sculpture objects, and he used them to replace the actors in the performances he organised. He had found that when they were exhibited, immobile, he had had to spend too much time explaining

BOY, OH BOY, AM I LIVING! 1964

Wood, metals, plastic, canvas, leather, with electric motor, in metal frame

1988 x 1499 x 381 T02023

Some of the pieces in this work were already in the artist's home, some he set out to find elsewhere. The limbs came from the Limb Fitting Centre at Roehampton, the head from a Dutch Belisha beacon. The torso is made from a water geyser. The fact that the elements came from medical and dental sources was entirely apposite, as Lacey wished to express his fears about developments in spare part and brain surgery. Lacey liked to let the pieces inspire the construction.

127

them, and that they worked better actively. In the seventies his machine-constructing activity shifted to making light and sound systems for his performances.

JOHN DAVIES
b.1946

Davies studied painting at Hull and Manchester Colleges of Art. After two years at the Slade, he won a sculpture fellowship at Gloucester College of Art. His sculptures were first exhibited at the Whitechapel Gallery in 1972, and caused something of a stir. This was partly due to the fact that they were not abstract, but also to their essentially disturbing nature. Davies was not then aware of potential similarities between his work and the American photo-realist sculptors of the time. His figures have elements – heads, hands etc – cast from life, and their clothes are culled from the real world. During the seventies he grouped them, thereby exploiting suggestions of dominance and subservience. He always used young men, as if they were his own substitutes. After 1980, Davies abandoned casting from life, and in turning to modelling, turned to a much smaller scale. These little, acrobatic figures were produced at the same time as a series of very large heads, and Davies plays on shifts of scale such as we experience all the time in our experience of people around us. The relationship between spectator and performer has been increasingly exploited, and we are drawn into Davies's exploration of how we perceive and relate to each other.

YOUNG MAN 1969-70
Painted polyester fibreglass and inert fillers, wool, cotton and leather
1803 x 508 x 279 T02382

Davies wants the spectator to confront the sculpture as if it were a person, not an object on a stand. He requires a realistic aura for his sculpture, aiming to dispense with any associations of style, artist or period. All such qualities should 'fade away'. The deadening, masked quality of these realistic figures, who are so like ourselves, is what makes us uncomfortable. Davies began work on the sculpture whilst teaching at Cheltenham Art College; an art student took a mould from his head and body and Davies cast the mould from his own hands. Final casting of the head may have been completed at that time but the overall casting in polyester resin was completed at his studio in Faversham, Kent. The jacket had been worn by Davies but the rest of the clothing and the nylon wig were bought at jumble-sales.

Much of what has been said in the introduction to the preceding section holds good for this one. However, whereas the previous section showed artists who have become increasingly marginalised, this section, though including artists of the same age or little younger, acknowledges the relevance of these sculptors today to the 'New British Sculptors' who have gained notable international recognition in this decade. Nor, in fact, are the 'New Sculptors' them-selves really distinguishable by age, for they are not much younger. What distinguishes this section from the last is its currency in the art world of today.

These 'New British Sculptors' – Tony Cragg, Richard Deacon, Antony Gormley, Shirazeh Houshiary, Anish Kapoor, Richard Wentworth, Alison Wilding, Bill Woodrow – produce very varied work. That they are grouped to-gether is to some extent due to the fact that they have been, from the beginning, exhibited together. They began to exhibit their mature work around 1980-1981, and a number of them came together in the exhibition *Objects and Sculpture,* at the Arnolfini in Bristol, and at the I.C.A. in London. The group image has been strengthened by a number of international exhibitions. In 1982 Cox, Cragg, Deacon, Kapoor, and Woodrow were exhibited in Lucerne; in 1983 Cragg, Deacon, Gormley, Kapoor, Wilding and Woodrow at the Bienal de São Paulo. This grouping has only been strengthened in recent years. The fact that a good number of these artists are represented by one gallery has also reinforced the group identity.

Several exhibitions have presented this group of younger artists in the context of a preceding generation (eg *Between Object and Image,* Madrid 1986, *A Quiet Revolution,* Chicago

1987, and indeed, *Starlit Waters* recently held here), and the 'chosen' preceding generation has been quite specific. Barry Flanagan and Richard Long are notable constants in a 'generation' that includes Michael Craig-Martin, Ian Hamilton-Finlay, Hamish Fulton, Bruce McLean and David Nash.

If we continue the attempt to identify artists' groups by their art school training, we might note that a number of these artists attended the Royal College. Richard Wentworth, Alison Wilding, Tony Cragg, and Richard Deacon were there, respectively, between 1966 and 1977. (Kate Blacker and David Mach are more recent Royal College graduates). David Nash, Bill Woodrow, Shirazeh Houshiary and Anish Kapoor were all at Chelsea; the former two in the early, the latter two in the late, seventies. The sculpture department of the Royal College was indeed undergoing a lively period c. 1968-75. Sculptors working there were interested in sculpture as sym-bol or metaphor; as a collective identity of things so combined with their workspace that they produced metaphysical associations. (Some of these sculptors have been mentioned in Section Eight; others such as Boyd Webb and John Cobb also helped to foster an alternative rationale to that at St Martin's.)

Although these younger British sculptors have been seen as a generational reaction to the international avant-garde culture of the seventies, they are not isolated nationally, but in fact relate to broader cultural specifics. Some of their topicality and subsequent celebrity must be due to the international 'return to the subject' of contemporary painters. However, they have retained a crucial concern with material and process. Moreover, they do not represent a simple reaction to what has gone before them in British sculpture, but have drawn on the diverse interests of the two preceding 'waves'. They have accepted the condition of the

'objecthood' of the sculpture of Caro and the New Generation, and, along with it, the belief that sculpture can acceptably be presented in art galleries. They have also drawn inspiration from the conceptualism of the next generation of St Martin's students: Long, McLean, Flanagan and Gilbert and George. The New Generation had presented sculpture as something to be looked at. The next generation had challenged this. At present, sculpture is once again something to be looked at. The 'New British Sculptors' have gone back to the object and moved away from a concentration on its means of promotion (ie the mechanisms of production, publication, distribution and display). Visible is a rapprochement of form and content. The allusion and the metaphor are notably present. Their art is less private, for its poetry and metaphysic allows it to enter and be reborn in the mind of the spectator. Their sculpture may rest on a conceptual basis, and yet simultaneously present a slice of reality. Fenella Crichton's understanding of Wentworth has wider relevance: 'With great precision Wentworth gives things that small but intrinsically poetic shove which enables them to speak to us not only about the language of art, but also about the world in which we live'. Some of their work relies on simple means and immediacy; some of it on sensuality and erotic ambivalence. All of this, however, is new to avant-garde British sculpture.

'I have no formal concerns;', Kapoor has stated, 'I don't wish to make sculpture about form – it doesn't really interest me. I wish to make sculpture about belief, or about passion, about experience that is outside of material concerns'.

Similarly, Cragg recalled, 'For me, in the mid-seventies, the crucial question became one of finding a content, and from that came the idea that might evolve through a more formal approach to the work'. Such a problem was, in the mid-seventies,

widespread; and it meant that for many of these sculptors, it was a fallow period. They had been presented with two opposing options: they could be sculptors but not sculpt, or they could be sculptors discursing solely in the language of sculpture (William Tucker's brief as presented in his Hayward selection of 1975). Neither seemed an adequate solution, and they chose neither. Instead, they have sought to reintegrate the two alternatives; to fuse more thoroughly 'art' with 'life', and to do so with sculpture that is more permanent and tangible than that of their immediate predecessors.

BARRY FLANAGAN
b.1941

Flanagan was born in Prestatyn. He studied architecture and sculpture at Birmingham, and from 1964 to 1966 was enrolled in the sculpture course at St Martin's. His work has gone through several distinct phases, while always displaying a concern for the properties and processes of material. At his first one-man show in 1966 he exhibited a cone of sand with a concave top caused by the removal of some sand. In the same period he filled rough cloth sacks with paper, foam or sand, and these sculptures forcibly challenged our received notion of sculpture as something set in one position to stay that way. Flanagan felt that previous 'hard' materials were too labour-intensive, and thus prevented the artist from working easily and naturally with his material. After visiting Italy in 1973-4, Flanagan began to use stone. The resulting sculptures were mounted on little altar-like pedestals which, though more traditional, were nevertheless only loosely put or stacked together. The first of his popular bronze hares first appeared in 1979, and has since been mounted on various celebratory pedestals. Other animals have joined the hare: elephants, horses and unicorns. Flanagan was Britain's sole representative at the Venice Biennale in 1982.

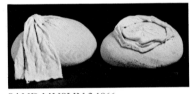

SAND MUSLIN 2 1966
Two muslin bags filled with sand
Dimensions variable, width c.305
T03725

'Sand Muslin' dates from the year in which Flanagan left St Martin's. The sand filled bags, like many of Flanagan's 'soft' sculptures, apart from subverting the traditional nature of sculpture, and unsettling the collector or curator, have a 'vulnerable, animate' quality. They reflect Flanagan's interest in the shapes made by materials of their own volition, without the imposition of the artist's will.

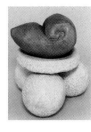

CARVING NO. 2

White Arni Marble and Grey Imperial Marble
622 x 610 x 610 T03609

This work is the second from a series of thirteen, produced in 1981 at the Ghelardini atelier at Pietrasanta, Italy where craftsmen worked from quarter-size, clay maquettes made by Flanagan. Although some of Flanagan's work from the 1960s deliberately avoided the use of traditional sculptor's materials (choosing instead, sand, hessian, linoleum, blankets etc), his interest is fired as much by working in sheet-steel, bronze and marble and by working with craftsmen, skilled in the handling of those materials. Many such works had involved the process of 'scaling-up' from the forms of his original models. 'Form shaped by the cupping and squeezing together of both hands, of clay, will have a very delicate and exact form … this is a challenge, clearly, to any stone carver, to reproduce this form or even to appraise it'. The maquettes were enlarged by four times because the dimensions of an arm are four times that of the hand; Flanagan pays homage to the shared process of enlargement.

GILBERT & GEORGE

(b. 1943 and 1942)

Gilbert and George met at St Martin's School of Art in 1967, and have since worked in collaboration. Gilbert had previously studied art in Germany, George at Darlington Hall and Oxford. Gilbert and George present themselves as 'living sculptures', and between 1969 and 1977 presented various shows in which they performed. These included 'Meeting Sculptures', 'The Singing Sculpture', 'Lecture Sculpture', and perhaps most famously, 'Underneath the Arches'. In this they bronzed their hands and faces, stood on a table, and accompanied the taped song. Their performances, frequently lasting several hours, were punctuated only by their re-winding of the tape. Gilbert and George represented

statues who represented tramps. They use this 'other' side of society – tramps, graffiti, obscene language, the harsher side of life – in their art, in which they have also experimented with the effects of drunkenness. They claim, however, that 'There's no correct political line on our works. We are interested in morality'.

Since 1971 they have produced photo-pieces, and although they rely heavily on artifice in the darkroom, they are not interested in presenting this process to their audience. 'The picture should be completely smooth, as if it had been shot out of our brains, onto the paper like magic'. They are interested in the single art experience, not in narrative. 'People want something so immediate that they can just say, "That's fucking good".'

At first many small photos were grouped together; later a grid framework has held the photos together in one frame. They have steadily incorporated more colours into their works, which began in black and white. In the earlier works Gilbert and George were the subjects, and they were in every photo-piece until 1980. They believe that 'art is there for the meaning', and that 'art-art' is very wrong. They present themselves as Art's sculptors, and like the notion of the 19th century artist, in frock coat, as the priests or philosophers of society. The 20th century notion of artist as freak is anathema to them. They refuse to be categorized as modernist, and appear to regard modernism as being devoid of meaning and higher purpose.

BALLS: THE EVENING BEFORE THE MORNING AFTER – DRINKING SCULPTURE

Black and white photographs between glass, card and passe-partout

2108 x 4382　　T01701

The title for this piece derives from the name of the wine-bar Gilbert and George frequented around 1972, 'Balls Brothers' on the Bethnal Green Road, London. The management allowed them into the wine-bar after closing time to take a series of photographs and to pose for a non-professional photographer. The artists were looking for things to catch their eye, things that would make a good photograph and therefore adopted an instinctive approach to the selection of images for the work. All photographs were developed in the dark-room at their studio ('ART FOR ALL', Fournier Street, London), again with an instinctive choice of paper-sizes from a range of commercial sizes available. Although interested in the effects of alcohol on themselves as living sculptures, and on their ability to communicate with the public, Gilbert & George drank no alcohol while taking these photos. However, some of the photographs were printed so as to simulate some aspects of drunkenness (blurring, distortion etc.)

DAVID NASH
1945

Between 1950 and 1967 Nash spent every summer in the slate-quarry town and valley of Blaenau Ffestiniog, and he now lives there with his family: this association has become central to his output as an artist. In 1968, he discovered Capel Rhiw, an abandoned chapel which he bought immediately and converted into his home and studio. Nash did a Foundation course at Kingston College of Art (1963-4), spent a year on the painting course at Brighton College of Art but returned to the sculpture class at Kingston where he studied until 1967; in 1969 he did a one-year postgraduate course at Chelsea School of Art. Nash began by working with standard units of milled wood, painting it, so as to 'put colour into space', which he did with a series of thirty foot towers. He moved from painting to staining to using the wood's natural colour.

Simultaneously, he started to use trees rather than planks, and left the traces of his chisel or axe visible in the work. Nash used only fallen trees, preferring not to fell living ones, but more recently has begun to use living trees in his work; growing and 'weaving' them so that they are growing sculptures. He is interested in the process of change exacted by weathering and time, and has also taken advantage of wood's natural characteristics, such as splitting, to create particularly humorous images.

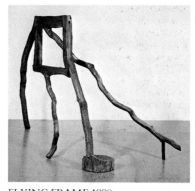

FLYING FRAME 1980
Oak
2160 x 3430 x 1200 T03932

'Flying Frame' was constructed from the branches of an oak tree given to him by the owner of Tan-y-Bwlch, an area of woodland near the artist's home in Wales. Working *in situ*, Nash extracted a number of sculptures and ideas from the one tree; in another Tate Gallery work, the drawing 'Family Tree 1970-82' Nash has illustrated this process whereby every distinct element of the fallen tree evokes its own function within a sculpture. This 'Flying Frame' is related to tables and cubes in that the angles created by natural branch growths are incorporated into a geometrical structure. The rough wood-cuts (usually administered by a large axe) betray Nash's straightforward relationship to his raw material and a workmanlike sense of economy in both time and motion. The idea of a frame wittily relates to a picture frame, and the sculpture does indeed frame a landscape or view.

RICHARD LONG
b.1945

A SCULPTURE IN BRISTOL 1965

*Seven black and white photographs mounted on board
and one title panel*

276 x 276 (x eight panels) T03808

Long was content in 1965 merely to
record this experimental sculpture of a
'fictional abstracted river system' which
he made in the garden of a derelict house
in Bristol. It was not until 1983 that he
organised the photographs into a finished
piece for his show at the Arnolfini Gallery
in Bristol. By digging trenches in the turf,
lining them and filling them with liquid
plaster, Long was able to recall the
appearance of the River Avon and its
tributaries at low tide. This is an example
of a deeper probe of the earth's surface
than is usual in Long's work but is
consistent with his sustained interest in
the appearance of negative space in the
landscape. The work is a homage to the
central place held by the River Avon's ebb
and flow in Long's experience of
landscape.

EAST DART RIVER	INTO A LOW SUN
LONGFORD TOR	GLISTENING FROST
LITTAFORD TOR	FOX TRACKS
CROCKERN TOR	BETWEEN THE GRANITE
WEST DART RIVER	DOWN FAST GROUND
ROYAL HILL	OVER A DRY WALL
STRANE RIVER	BOGGY AND SLOW
RIVER SWINCOMBE	ACROSS STEPPING STONES
FOXTOR MIRES	LEAPING
GREAT GNATS HEAD	FLOATING GROUND
BROAD ROCK	SUN SETTING
LANGCOMBE HEAD	CREAKING ICE
YEALM HEAD	FULL MOON RISING
DENDLES WASTE	DARKNESS

TWO STRAIGHT TWELVE MILE WALKS ON DARTMOOR
PARALLEL ½ MILE APART OUT AND BACK ONE DAY
ENGLAND 1980

TWO STRAIGHT TWELVE MILE WALKS ON DARTMOOR 1980

Screenprint

1022 x 1521 T03161

Long had first exhibited a words-only
image in 1969 at the *When Attitudes become
Form* exhibition in Berne. This was a
printed poster. Later word-works were
printed in books, painted or pencilled on
gallery walls. Long records salient points
of walks in a kind of evocative shorthand:
names of places, dates, times, things seen.
In this work, the left column lists the
places on the walk in order from the
bottom; they correspond with the
experiences or incidents on the right. It
was designed as a poster which could be
pasted directly onto a wall.

STEPHEN COX
b.1946

Stephen Cox was born in Bristol, studied there, and at Loughborough and Central School of Art 1964-68. He first exhibited in London in 1976, and has since exhibited widely in Britain, Italy and elsewhere. Cox's early works were smoothly plastered free-standing walls. These were the exposition of a craft mastered by Cox, and of the pleasure in material (the crystalline structure in the plaster attracting the light) and good craftmanship. He gave these pieces titles evocative of the sublime element in American Abstract Expressionist painting. He transferred some of the qualities of these walls to his next series executed in marble. He leant marble slabs against the wall and incised on them simple configurations which suggested perspective and depth.

This interest in architecture led him to create architectural shapes (lunettes, circles and arches), at first with stone slabs tightly packed together, latterly distributed more loosely.

His interest in stone is connected with his interest in Italy; fine Italian Renaissance stone carving, and the different Italian marbles are sources of stimulus.

Similarly the architecture and ruins of the Italian civilization have been powerful attractions. His work is a conscious continuation of this tradition, and relates to a contemporary interest among painters to reinstate artistic 'Tradition' as content in their work. He has spent increasing amounts of time in Italy since 1979.

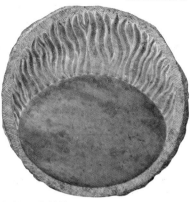

TONDO 1981
Sant' Ambrogia di Verona marble
667 (dia.) x 70 T03356

'Tondo' is made from red marble from Verona, where it was carved under Cox's supervision by local craftsmen. Stephen Cox is very interested in traditional Italian carving, and he has tried to use all the marbles mentioned by the 16th century art historian Vasari. Adrian Stokes, a British art historian of this century who also loved the effects obtained in stone by Italian Renaissance craftsmen, thought that Verona marble produced a particularly lovely 'stoneblossom'. The title of the work uses Stokes' question in the last paragraph of his *Quattro Cento* , 'I have written not only for the unfortunate Northerners who love the South, but for those who love the North passionately, so that they might know the essence that is foreign and dangerous to their art. Or do we all need light in the place of lightning ... must we always turn South?'

RICHARD WENTWORTH
b.1947

Wentworth was born in Samoa. He studied at the Hornsey College of Art and at the Royal College, and in 1967 worked briefly with Henry Moore. Between 1971 and 1988 he taught at Goldsmiths' College, and has spent two periods living and working in New York. He first exhibited in 1969 and has since been represented in many major survey shows of contemporary British sculpture. Wentworth has been described as a 'punning' artist, aware of the conventions of language and their arbitrary nature, attempting in his work to make sense out of the associations between words and objects. He stresses, however, that he is not interested in creating visual puns, and prefers to think of his work as 'analogous to rhyming slang'. Titles always play an important part in his works, but their effect is always played out on a visual plane. He forges images from diverse elements. Wentworth adds to and subverts ready-made objects; frequently he upsets their balance, yet does not allow them to fall over. Wentworth has a lecture/theme entitled, 'Making Do and Getting By' which dwells on his interests in the ways in which we all use ordinary objects for purposes quite different to their original functions. Although he has remarked that Minimalism and Surrealism are diametrically opposed, his work appears to go a long way in bringing them together. Wentworth is enthusiastic about the

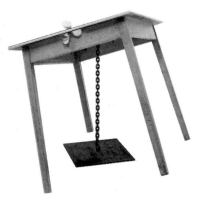

SHOWER 1984

Mixed media

890 x 1100 x 880 T03924

Wentworth has said that he was inspired to make this after seeing a café-owner rush out of his café during a shower and upend the terrace tables against the wall. The 'anchor' element probably refers to the way in which café tables are pierced and anchored to the ground by parasols. Formally we feel as if the anchor is ensuring that the table does not fall over, but in fact the table can stand by itself.

Surrealist spirit in its original form, but not about the way that it has been debased into a glossy, high-street art.

ALISON WILDING
b.1948

Wilding was born in Lancashire. She studied at the Nottingham and Ravensbourne Colleges of Art, and then at the Royal Academy 1970-73. Her first one-woman show was in 1976, and she has since exhibited widely in group and solo shows. Her earlier work was characterized by its transformations of ordinary objects; for instance paper bags remade in brass and zinc and encircled by a strip of metal. She has become less concerned by the installation of her work, and more with the work itself. Even the smallest of her often small sculptures has tremendous and commanding presence; there is a sense of levitation in her works. She frequently combines two very different materials; results stem from her own explorations in carving and construction which replace any preliminary drawing. The final composition both derives from and provokes, pragmatic and poetic considerations. The elegant simplicity and open honesty of her compositions relates them to the tradition of modernist sculpture including Brancusi and Hepworth. Her wall-mounted work makes a particularly personal contribution to contemporary sculpture. More recently she has produced a series of vertical pieces or vessels drawn from the female body and female experience.

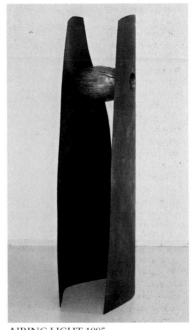

AIRING LIGHT 1985
Steel and brass
2450 x 927 x 610 T04912

'Airing Light' illustrates Wilding's tendency to juxtapose two elements and two materials. The basic constructive approach to making a sculpture is evident. As the sheets of steel touch at one side on the floor, one has the impression that they have been prised open to reveal their 'pearl'. The open-ended brass form and the holes in the steel sheets are a perhaps surprising factor in a sculpture that one might expect to be closed.

BILL WOODROW
b.1948

Woodrow studied at Winchester, St Martin's and the Chelsea Schools of Art 1967-1972. He had a one-man show as early as 1972, but was not able to build-up a body of work until after he obtained a studio, in 1978. He used urban scrap as the material for his sculptures, and went about examining its material nature by adopting a reverse or negative process. He took apart complicated household machines completely, and very neatly, or buried them in plaster or concrete and then began to rediscover them as if they were archaeological finds or 'contemporary fossils'. In 1980-81 he began to create a series of 'spawned' or 'parasitical' creatures, fashioned out of 'mother' creatures. The use of urban detritus is bound up with Woodrow's comments on our throwaway, leisure-oriented society.

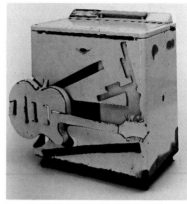

TWIN-TUB WITH GUITAR 1981
Washing machine
889 x 762 x 660 T03354

In 1980 Woodrow had 'unmade' bicycle frames, and, deciding to remake them, took a spin-dryer from which to fashion a bicycle frame. Within the following year Woodrow made four sculptures from typical heavy white domestic objects such as spin dryers and washing-machines. In each instance, a new object is created from the skin of an existing one, by a process like that of cutting a three dimensional model from the printed outline on a cereal packet. Woodrow's use of domestic methods and consumer materials is a conscious refusal of the high art tradition. The image of the guitar was chosen because it was something the artist would like to have owned. It has always been central to art that the artist can create 'something' from 'nothing'. The host machine revealed quite clearly in the negative the shape of the new object attached to it. The host machine, functional and mundane, gives birth to an item from another world, that of entertainment.

TONY CRAGG
b.1949

Cragg was born in Liverpool and studied art at Gloucester, Wimbledon and the Royal College 1969-1977. Since 1977 Cragg has lived in Wuppertal, and he teaches in Dusseldorf. From the outset, Cragg has worked with found objects. In 1970 he produced a collection of sea-shore objects arranged on a chalked grid, and in the seventies laid or stacked pieces, especially wood, on the floor. In 1978 Cragg began to use colourful plastic debris, at first arranged in rectangular zones of colour and later forming images, at first

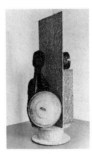

Tony Cragg
Taxi 1984
(work not in exhibition)
Photo courtesy of Lisson Gallery

MINERAL VEIN 1986 (Not illustrated)
Wood
2110 x 1195 x 815 T04866

'Mineral Vein' is another illustration of Cragg's theory that we must learn to reformulate our ideas about the everyday

on the floor, and later arranged on the wall. By 1981 Cragg incorporated wood and glass into the work. The images include maps of Britain, riot police, goalkeepers and cowboys. Since 1984 free-standing sculptures in the round have appeared, some combining ready-made utilitarian items with plastic or stone, others using geometric wooden forms stacked together in a manner reminiscent of hillside villages or mountains. His interest in monolithic forms has been confirmed in recent years with his pieces cast in iron, in glass, and turned in stone. Cragg is interested in the man-made environment around us, which though not natural in origin, has in fact become our new 'nature'.

DAVID MACH
b.1956

Mach was born in Methil, Fife and studied at Duncan of Jordanstone College of Art in Dundee and at the Royal College of Art from 1979. On graduating in 1982, he was awarded the RCA Drawing Prize and took a post as part-time lecturer at Kingston Polytechnic's Sculpture Department. Since 1981, Mach has exhibited widely in one-man and group shows throughout Europe and America.

He uses large quantities of industrially manufactured goods, arranged in temporary installations at a given exhibition venue, by a team of helpers. The sheer amount of material surprises the spectator, relates to contemporary over-production, and refutes the sculpture's saleability as an 'art-object'.

man-made world, and to bestow on it the appreciation which we normally reserve for works of art. Painting an ordinary cabinet in a manner reminiscent of precious stones or of skilled marbling techniques is a simple way in which to present this proposition.

THINKING OF ENGLAND 1983
Glass, lacquer and water
200 x 1680 x 2330 T04858

The bottles relate to the earlier stage in Mach's career when he used multiple identical objects that were simply empty or discarded. By discreetly altering them, he provides them with content; filling empty vessels with meaning. Here he combines an image of a prostrate woman with a Union Jack; the title lightheartedly conflates an attitude to the 'homeland' with implicity sexual overtones. Mach has since moved on to using objects that are specifically value-laden; objects of desire such as motorbikes, cars, toys and shoes.

JULIAN OPIE
b.1958

Opie was born in London, and studied at Goldsmiths' School of Art between 1979 and 1982. Opie uses subjects culled from his everyday life and experiences. He uses steel sheets to recreate the objects, drawing on it and cutting it out directly. He sees himself as drawing rather than painting or sculpting. 'I find oil paint the easiest thing to draw with. Steel has proven the most versatile and speedy material. Oxy-acetylene welding and cutting is hot, messy and has a boring macho tradition, but you can draw with the torch almost as with a pencil. You can weld things together in positions that would be impossible in other materials. Steel can be bent or folded, and as it has no texture, can be made to imitate most things'. The fact that the paint is applied in a casual, shorthand style makes it obvious that Opie is not interested in trompe l'oeil illusions, but in creating new realities. Paint makes the objects easily recognizable, giving them their outstanding characteristics, but it also creates a tension with the three-dimensional nature of the sculpture which takes us back to Picasso's cubist constructions. The honesty of Opie's artifice is in fact what is intriguing.

MAKING IT 1983
Painted steel construction
2610 x 1180 x 1925 T03783

Opie encourages the observation that his work falls somewhere in the category between painting and sculpture. Opie looks upon the steel as a simple support, much like a canvas and has subsequently made a playful reference to the 'tradition' in Modern sculpture and painting of betraying how the work is assembled and what it is made from. By making a sculpture 'in action', in the process of making itself – with the most 'toolish' kind of tools – Opie is presenting a behind-the-scenes story of a sculpture. He explained this as being a comment about the sculpture of the seventies, but more importantly, it's about 'one thing doing something to another like a match lighting a cigar. This gives a reason to the match and cigar, or the tools and the sculpture. They support each other – visually and physically'. The tools were made in the most direct way – by drawing their outlines onto sheet steel with chalk, cutting them with a welding torch, bending them into shape and welding them together.

SELECT BIBLIOGRAPHY

M. H. Spielmann *British Sculpture and Sculptors of To-day* London, 1901

Kineton Parkes *Sculpture of Today* (vol 1) London, 1921

Roger Fry *Transformations, Critical and Speculative Essays on Art* London, 1926

Stanley Casson *Some Modern Sculptors* London, 1928

Eric Gill *Art-Nonsense and Other Essays* London, 1929

G. A. Jellicoe 'Modern British Sculpture' *The Studio* January 1930 vol XCIX No 442

John Grierson 'The New Generation in Sculpure' *Apollo* November 1930 Vol XII no 71

Kineton Parkes *The Art of Carved Sculpture* (vol 1) London, 1931

Stanley Casson *XXth Century Sculptors* London, 1930

Herbert Maryon *Modern Sculpture: Its Methods and Ideals* London, 1933

Unit 1: the modern movement in English architecture, painting and sculpture (ed) Herbert Read, London, 1934

Axis: A quarterly review of contemporary abstract painting and sculpture January 1935–Early Winter 1937 8 issues

Circle: International Survey of Constructive Art (ed.) J. L. Martin, Ben Nicholson & N. Gabo, London, 1937 (Reprinted 1971, Northampton)

E. H. Ramsden *Twentieth Century Sculpture* London, 1949

A. D. B. Sylvester 'Festival Sculpture' *The Studio* September 1951 vol CXLII no 702

John Anthony Thwaites 'Notes on some young English Sculptors' *The Art Quarterly* Autumn 1952 vol XV no 3

Lawrence Alloway 'Britain's New Iron Age' *Art News* Summer 1953 vol LII

Herbert Read *Contemporary British Art* Harmondsworth, Middlesex, revised edition 1964 (originally published 1951)

Gene Baro 'Britain's New Sculpture' *Art International* June 1965 vol 9

Gene Baro 'British Sculpture: the developing scene' *Studio International* October 1966 vol CLXXII no 882

George Rickey *Constructivism: Origins and Evolution* New York, 1967

Charles Harrison 'London Commentary: British Critics and British Sculpture' *Studio International* February 1968 vol CLXXV no 897

'Some Aspects of Contemporary British Sculpture' Special issue of *Studio International* January 1969 vol CLXXVII no 907, including Charles Harrison 'Some recent sculpture in Britain'

William Tucker *The Language of Sculpture* London, 1974

Charles Harrison *English Art & Modernism Vol I 1900-1939* London, 1981

British Sculpture in the 20th Century (ed) Sandy Nairne and Nicholas Serota, Whitechapel Art Gallery London 1981

Sculpture in Britain Between the Wars introduction by Benedict Read and Peyton Skipwith, Fine Arts Society, London 1986

British Art in the 20th Century: The Modern Movement (ed) Susan Compton, Royal Academy, Munich 1987

Terry A Neff (ed) *A Quiet Revolution British Sculpture since 1965* London 1987